How To
Photograph
Landscapes

How To
Photograph
Landscapes

Joseph K. Lange

STACKPOLE
BOOKS

For my mother, Lois,
who taught me to appreciate art
at an early age.

For my wife, Bonnie,
who has always encouraged me
to pursue publication of
my landscape photography.

Copyright © 1998 by Stackpole Books

Published by
STACKPOLE BOOKS
5067 Ritter Road
Mechanicsburg, PA 17055

Printed in China

First edition

10 9 8 7 6 5 4 3

Cover design by Wendy Reynolds

Cover photo: "Tetons Reflection," Grand Teton National Park,
Wyoming

Page vi: "Sandstone Butte at Sunset, Paria River," Vermilion Cliffs
Wilderness Area, Arizona

Library of Congress Cataloging-in-Publication Data

Lange, Joseph K.
 How to photograph landscapes / Joseph K. Lange.—1st ed.
 p. cm. — (How to photograph)
 Includes bibliographical references (p.).
 ISBN 0-8117-2456-5 (paperback)
 1. Landscape photography. I. Title. II. Series.
TR660.L38 1998
778.9'36—dc21 97-44031
 CIP

CONTENTS

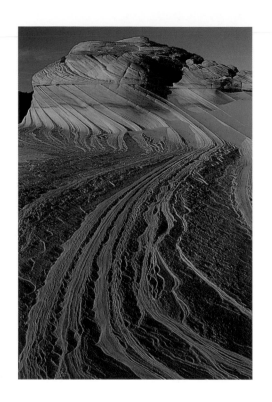

PREFACE

I grew up in a suburb of Chicago. My mother was an art teacher, and during my formative years, she taught my brother and me about composition, colors, drawing, and painting. We studied classic art painted by the masters and often visited the Art Institute in Chicago.

One summer my father took us on vacation to the western United States and Canada. We visited the Tetons, Yellowstone, Glacier, and the Canadian Rockies before returning to Illinois. This glimpse of the beautiful scenery in the West changed my life forever. I felt a need to record the beauty I had seen, and my interest in photography was born.

I purchased my first camera, a Kodak Pony, at age ten from the Sears Roebuck catalog. It was an adjustable camera, and I learned about shutter speeds, f-stops, and depth of field by reading the instruction booklet. Fortunately, our family went west several more times, and I took slides of the scenery. After I graduated from high school in 1959, I enrolled at the Colorado School of Mines near Denver, not only to pursue my education in geology and geophysics, but also to live in the West, where I could enjoy scenic photography.

After graduating from college, I spent two years in the army at Fort Lewis, Washington. During my two years in the service, I purchased my first single-lens reflex camera and a number of interchangeable lenses. The Pacific Northwest is a beautiful place, and I took many photographs in Oregon, Washington, and the Canadian Rockies. By trial and error I began to develop my own style and techniques of photographing landscapes. Fort Lewis had a craft shop that included a darkroom, and I found that I enjoyed black and white printing.

Upon leaving the army in 1966, I returned to Denver as an exploration geologist for Chevron Oil Company. I was assigned to the Plateau District of western Colorado, Utah, and northern Arizona, and my love affair with the Colorado Plateau began. Photography brought me much enjoyment, but I felt that something was lacking.

In the spring of 1969, I noticed an ad in the *Denver Post* for the Colorado Council of Camera Clubs Annual Convention. I decided to attend and was thrilled by the beautiful photography that was exhibited in the competitions and the quality of the photographic programs that were presented. I joined my first camera club the next week.

I didn't win much in the club competitions the first year, but I kept my ears and mind open during instructive programs and during evaluation of slides and prints entered in competitions, and I rapidly learned the fine points of composition and

lighting. I also learned from more experienced club members new skills such as wildlife, flower, action, and architectural photography. I competed in both slide and print categories. As my knowledge and skills improved, local and state recognition of my photographic efforts increased as well. Within a few years, I was regularly asked to present programs and judge competitions at other camera clubs.

In 1975, looking for new worlds to conquer, I began to enter international competitions sanctioned by the Photographic Society of America (PSA). These competitions demanded an even higher level of excellence. By the mid-1980s, I was one of the highest-ranking nature photographers in the world. I relished the competition and enjoyed the friendships that I developed with photographers all over the world.

My desire was to keep photography a hobby. I loved my regular job in international oil exploration and worked in this industry for twenty-seven years. In 1990, however, due to a radical downsizing of the oil business as a result of lower worldwide energy prices, I found myself out of a job. Knowing that obtaining another job in the oil industry would be extremely difficult without moving to some undesirable location such as Djakarta, Cairo, or Islamabad, I decided to try to make a living at photography.

I had marketed my photographs through a stock agency for a number of years and knew that the income generated from selling photographs, either directly or through an agency, was uncertain and inconsistent. I soon learned that despite the high recognition I had attained in the Photographic Society of America, the editors of the major photo magazines, as well as the average picture takers who read those magazines, were not familiar with my name or work. Even the successful marketing of photographic workshops is largely dependent on name recognition. It takes years to establish the relationships and reputation needed to become financially successful as a nature photographer.

I would like to express my sincere appreciation to Helen Longest Slaughter of *Nature Photographer* magazine for publishing several of my articles on the desert Southwest and using one of my images on the cover. I suspect that these articles prompted Stackpole Books to contact me and propose this book.

I am also deeply grateful to Stackpole Books for providing me with the opportunity to write this book. I appreciate the patience and guidance of Judith Schnell, Mark Allison, and Jon Rounds of Stackpole in editing the raw manuscript and helping to produce a book that I hope will be instructive and enjoyable. I would also like to thank my son, Robert, who has a degree in journalism, for making constructive suggestions on the content of the book. I would especially like to thank my wife, Bonnie, for continually encouraging me to try to get my photographs and ideas on nature photography published.

Introduction to Landscape Photography

Mesa Arch, in the Island-in-the-Sky District of Canyonlands National Park in Utah, frames the LaSal Mountains, Washer Woman Arch, and the canyons of the Colorado River 2,000 feet below. This is a location that I have visited numerous times over the years. Many photographs of Mesa Arch, some good and some mediocre, have been published in magazines, books, and even commercial ads. The arch is long and narrow, faces east, and is surrounded by extremely hazardous terrain. My first photographs of Mesa Arch, twenty-five years ago, were taken in the afternoon with light falling on the arch. I used a very wide-angle lens to include both abutments of the arch. This treatment left the objects framed by the arch too small to be recognizable and included too much bright, distracting rock below the arch and too much uninteresting sky above the arch.

I realized that I had to try an entirely new approach and went to Mesa Arch at sunrise. What a wonderful difference that made! The early-morning sun lit the underside of the arch and made it glow. Backlighting, due to the haze in the canyon below, made Washer Woman Arch stand out from the background. I also realized that I didn't need to include the whole arch in the composition.

The final piece of the puzzle, the fresh snow, came several years later. I presently live in Grand Junction, Colorado, about two hours from Moab, Utah, and the canyon country. Snow had fallen at our home the day before, and the forecast was for clearing skies. My wife, Bonnie, and I got up at 3 A.M. with the plan of photographing at sunrise in Arches National Park. As we drove closer to Arches, we realized that the lower elevations of the canyon country had not gotten any snow. So we changed our plans and went instead to the nearby Island-in-the-Sky District, where the elevations are 2,000 feet higher than in Arches. We had guessed correctly—about 6 inches of new snow were on the ground. Mesa Arch was the logical destination.

We hiked the half mile to the arch and arrived just as the sun broke the horizon. The snow was fresh and untracked. Ribbons of fog swirled around in the canyon below and were colored orange by the rising sun. Since we had previously scouted out the exact camera position we wanted, we wasted no time in finding our compositions. We photographed feverishly. Half an hour after sunrise, the sun no longer lit the underside of Mesa Arch, and the moment was gone.

This narrative illustrates many of the ingredients needed to produce an outstanding landscape photograph. First, there must be the ability to identify a potentially dra-

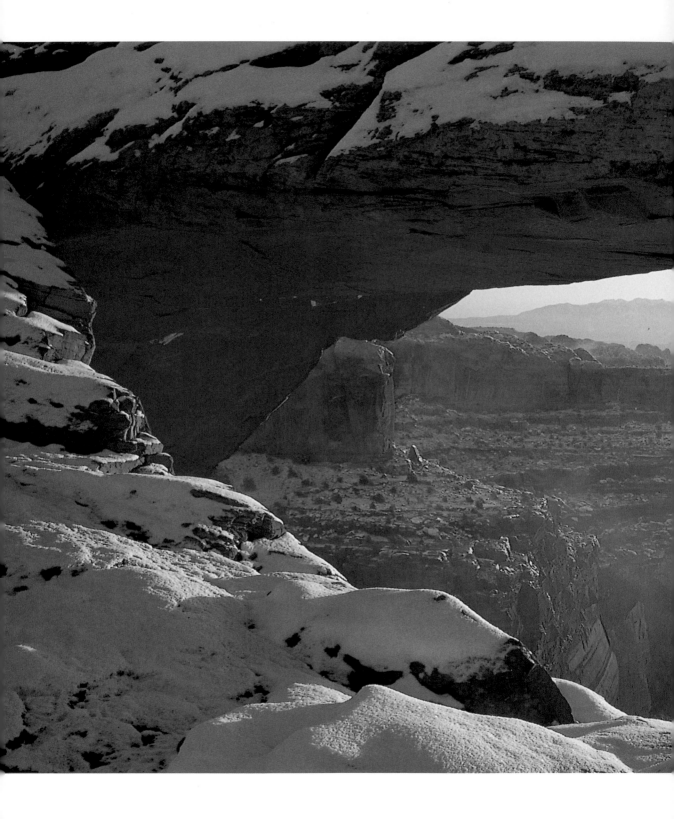

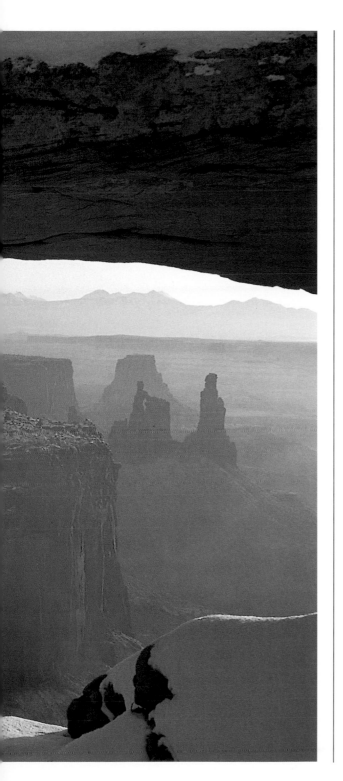

matic scene. Then, there must be the objectivity to analyze the results and try a different approach if needed. There must be the commitment to return to the scene as often as needed to determine the optimum time of day, time of year, and atmospheric conditions. There must be the anticipation that potentially excellent photographic conditions might occur and the dedication to get up at 3 A.M. and drive 100 miles on dark and snowy roads to reach the photographic location. There must be a thorough familiarity with the overall target area, so that subjects that would benefit most from the anticipated conditions can be identified. There must be the flexibility to modify the basic plan if conditions are not as anticipated. There must also be the willingness to endure cold fingers and feet, if necessary, to get the photograph. Finally, there must be the artistic ability to properly evaluate and compose the scene and the technical ability to determine the proper exposure and record the image.

In this book, I present my thoughts on the artistic techniques and technical skills needed to visualize and successfully record memorable landscapes, and try to convey some of the intangibles, such as preparation and attitude, that are required to be a successful landscape photographer.

Why Is Landscape Photography So Popular?

Photographing our natural world has tremendous appeal for photographers of all abilities. People of all walks of life have a special interest in the variety, mystery, and beauty of the world around us. Birds and animals are of great interest to many nature photographers, but the equipment needed to photograph

Winter sunset at Mesa Arch, Canyonlands National Park, Utah. *Minolta 35–70mm lens, polarizing and enhancing filters, Fuji Velvia film.*

these subjects may be too expensive, heavy, or complicated for some. Many of the best wildlife locations are in faraway countries that are too expensive and difficult for many photographers to visit.

Landscape photography, on the other hand, is much more dependent on artistry and technique than on expensive equipment. The basic equipment necessary for photographing landscapes—a single-lens reflex camera, several zoom lenses, a tripod, and a few essential filters—can all be purchased for less than one of the large

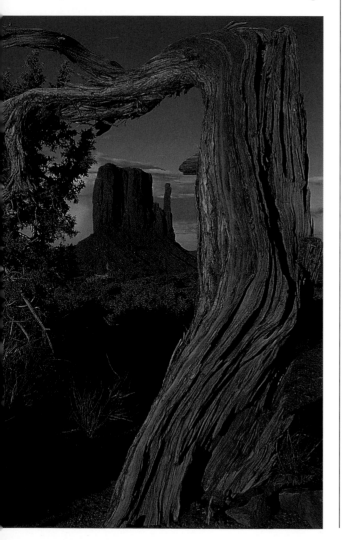

telephoto lenses favored by many wildlife photographers. This entire system for landscape photography, except the tripod, can be carried comfortably in a camera vest, medium-size backpack, or camera bag.

I have had the privilege of traveling extensively throughout the world as an amateur and later as a professional photographer. As a geologist for several international oil companies prior to becoming a full-time photographer, I visited all corners of the globe. But for those who live in the United States, it is not necessary to be a world traveler to find outstanding landscape material.

In my opinion, the United States has the greatest variety and highest quality of scenic wonders of any country in the world. From mountains, deserts, and seashores to forests, red-rock country, and thermal areas, outstanding landscapes beckon at every turn. People from all over the world come to view and photograph this country's outstanding scenic attractions. Even those with limited budgets or physical handicaps can find a variety of scenic subjects close to home to enjoy and photograph.

What Is Landscape Photography?

Initially, let me differentiate between a record shot and an artistic expression. A typical record shot shows a family member or friend standing in front of some natural or man-made feature. All it does is record that the person was there. On the other

The West Mitten at sunset, Monument Valley Tribal Park, Arizona. *Minolta 35–70mm lens, polarizing and enhancing filters, Fuji Velvia film.*

This gnarled juniper tree at the rim of Monument Valley makes a beautiful frame for the West Mitten. Because the tree was very close to the camera position, I chose an aperture of f/22, and focused at the hyperfocal distance to obtain maximum depth of field.

hand, when taking a landscape, or for that matter any kind of artistic photograph, the photographer is trying to tell a story and attempting to impart to the viewer a particular feeling or emotion. The photographer has control over all or most of the artistic elements needed to create this image: the type and composition of the subject matter; the quality, intensity, and direction of light; and the depth of sharp focus. Photographic tools including cameras, lenses, tripods, film, and filters are used to record the kind of image that tells the story. The emotional reaction of viewers to the resulting photograph is a function of how effectively these artistic and technical elements have been employed.

My definition of landscape photography is wide enough to include many man-made features. Although a large percentage of the landscapes I take have no evidence of the "hand of man," I sometimes include picturesque barns, country roads, and split-rail fences in my scenics, especially when they add positive compositional values to the photograph and enhance the story.

Landscape Photography—Past and Present

Landscape photography has not always been recognized as a valid and effective means of artistic expression. It was not until pioneer photographers such as Ansel Adams and Edward Weston attained critical acceptance of their landscape photography in the 1930s that the general public began to appreciate this type of image. Their accomplishments are even more astounding considering that the films and cameras they used were primitive by today's standards. Their success was due to the ability to evoke a strong positive emotional response from the viewers of their photography.

More recently, Joseph Muench, his son David Muench, Ray Manley, Ray Atkinson, and many others have added to the popularity and general acceptance of landscape photography. As a boy, the images of Ansel Adams and some of the other early scenic

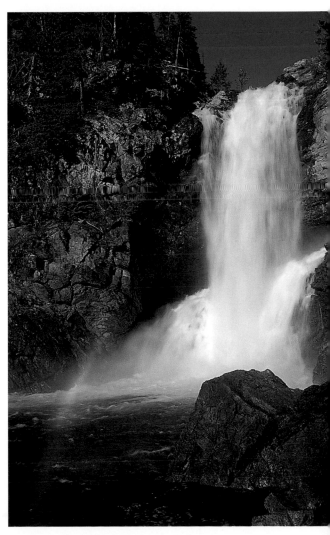

Running Eagle Falls, Glacier National Park, Montana. *Minolta 35–70mm lens, polarizing and enhancing filters, Fuji Velvia film.*

This waterfall in Glacier National Park is of particular interest because water flows over the brink of the falls and also from an opening near the base. The rainbow was enhanced by the use of a polarizing filter.

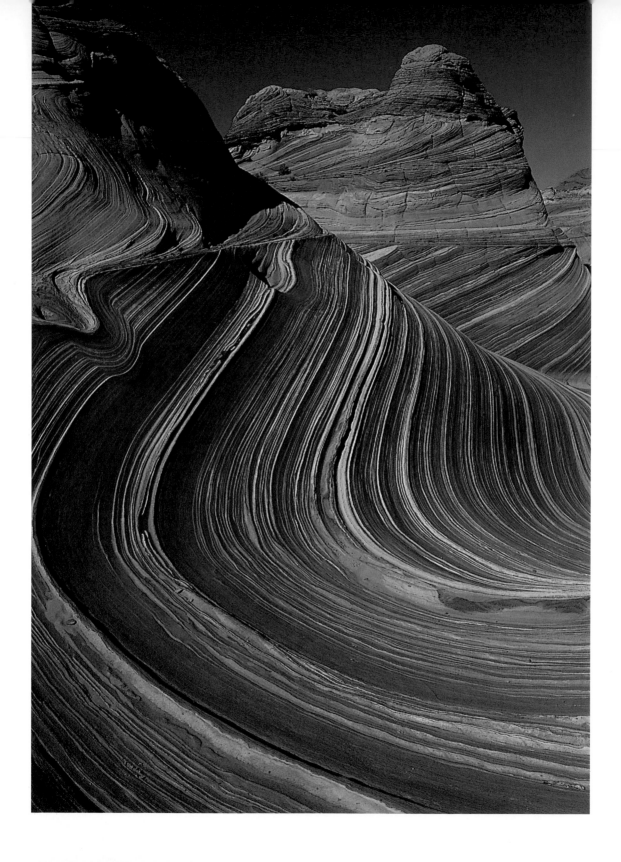

Sandstone patterns, the Bowl, Paria River–Vermilion Cliffs Wilderness, Arizona. *Minolta 24–35mm lens, polarizing and enhancing filters, Fuji Velvia film.*

The slickrock country in Utah and Arizona contains some spectacular patterns. I chose a very wide-angle lens to emphasize the curving lines in the foreground, which lead to the butte in the background. This area is very fragile, and those who enter it should tread lightly.

photographers provided me with the inspiration and incentive to pursue landscape photography on my own.

Several observations are worthy of note in looking at the résumés of these trail-blazing photographers as well as most of the current well-known wildlife and landscape photographers. Only a few had formal photographic schooling. Ansel Adams was trained as a concert pianist. Freeman Patterson has a degree in theology. Some had successful careers in other fields, which they left to pursue nature photography. Many of the well-known nature photographers were formally educated in a scientific field and learned their photographic skills informally. I believe that my education and experience as a geologist have enhanced my appreciation, and certainly my understanding, of the processes that created the scenery I now enjoy photographing.

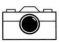

Composition: Telling the Story

Each landscape photographer has his or her own philosophy about what he or she is trying to convey to the viewer. My own objective is to establish that the world around us is beautiful and exciting. I am not primarily interested in reality, but in beauty. I employ every technique at my disposal, including composition, lighting, exposure, depth of field, choice of lenses, filters, and film, to make the scene as beautiful as possible. The resulting image has to be believable, however, so there are limits that cannot be exceeded in departing from reality.

I do not believe in looking for the ugly or seamy side of life to show how our civilization is destroying nature. Others can do that, if they wish. I believe in recording the beauty of nature so that persons who view my images are motivated in a positive sense to preserve this beauty. I do not feel, like some do, that the only way to preserve our scenic attractions is to make them inaccessible to the general population. Unfortunately, many people, including a significant number of national park rangers, hold this view. I think, rather, that a reasonable balance can be achieved between use and restriction so that most ordinary people can see and enjoy our natural wonders.

General Principles

Good composition is the glue that holds memorable images together. It is one of the two artistic pillars (the other being lighting) upon which all great photographs rest. It helps the photograph tell the story that the photographer envisioned. Good composition takes careful study and visualization of the final image.

Whether a composition is good or weak is a subjective judgment by each viewer. Statistically, however, a larger proportion of viewers will probably like some compositions and reject others. It is my opinion that most of the photography that the general population sees in the major photo magazines is, at best, substandard. This includes work by many photographers whose names are well known. Getting published, unfortunately, has far more to do with marketing than it does with photographic excellence. So where do inexperienced photographers go to see what good photography is and then learn how to evaluate and improve their own skills?

Local camera clubs, state camera club councils, and their parent national organization—the Photographic Society of America (PSA)—are wonderful places to learn high-quality photography. Local club meetings are usually held monthly, but some of the

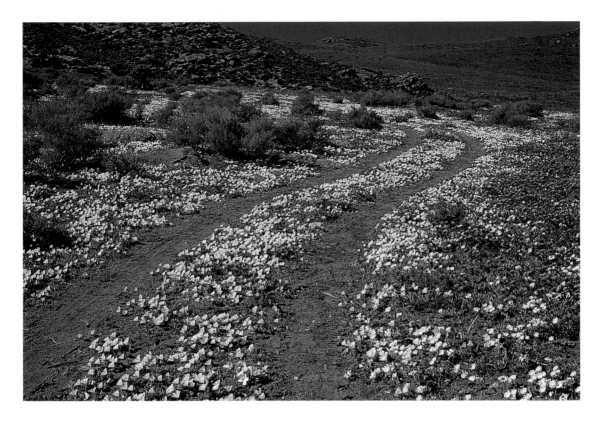

Road and spring wildflowers, Namaqualand, Cape Province, Republic of South Africa. *Minolta 35–70mm lens, polarizing and enhancing filters, Fuji Velvia film.*

Namaqualand, in the northwestern corner of South Africa, features possibly the most outstanding spring flower display in the world. The curving country road provides both the leading lines and center of interest that are so necessary for a strong image.

most active groups meet several times a month. Some local clubs are better than others, but at a good club, you'll hear instructive programs and witness competitions where your images, as well as those of the other members of the club, are evaluated by more experienced photographers. You'll also meet and become friends with a lot of nice people who share your enthusiasm about photography. Most of them are willing to share their expertise and techniques with newer members. This camera club environment stimulates newer members to be

active photographically throughout the year and, when coupled with regular evaluation and instruction, can produce rapid improvement in photographic skills.

Some photographers think that camera clubs are too restrictive and feel that they discourage new and innovative approaches. I don't agree. Certainly, camera clubs encourage a more traditional approach to photography, emphasizing excellence and attention to detail. Substandard work is not rewarded. Camera clubs have not joined in the rush toward mediocrity that began in

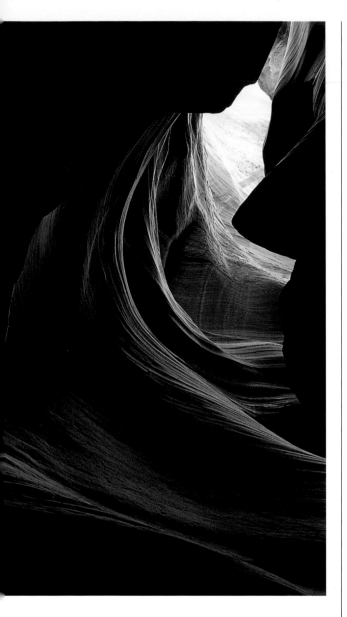

Slot canyon pattern, the Corkscrew, near Page, Arizona. *Minolta 35–70mm lens, 81A filter, 10 seconds, f/16, Fuji Velvia film.*

The slot canyons near Page, Arizona, are hundreds of feet deep and only a few yards wide. Spectacular patterns have been carved by flash floods over countless centuries. Direct sunlight seldom penetrates into the depths of these gorges but bounces around on the canyon walls, creating beautiful patterns.

In my many years of participation in local camera clubs, entering international exhibitions, and conducting photographic workshops, I've observed that a small percentage of individuals have a natural aptitude for good composition. These people need little guidance and find interesting compositions quickly and easily. Most other photographers, given an understanding of compositional principles, having the benefit of instruction in the field, and being willing to accept and learn from constructive criticism of their images, will progress rapidly in their compositional ability. And finally, there is a small group of individuals who have little or no feel for composition and refuse to listen to or accept constructive comments. Unfortunately, these people will never become good photographers.

Many compositional guidelines (I refuse to call them laws) have been articulated for years, and art schools still teach most of these principles, some of which go back to the days of the ancient Greeks. While I do not blindly adhere to these guidelines, I believe that all good photographers should be aware of them. Some of the most frequently mentioned guidelines are as follows:

• Don't place the horizon near the center of the photograph.

• Don't place the center of interest in the center of the photograph.

the 1960s, where the feelings of individuals are more important than the quality of their work. I firmly believe that becoming a member of a camera club will make you a better photographer. I give most of the credit for whatever success in photography I have attained to my education in the camera clubs and PSA, and I recommend them highly to others.

• Don't place bright or distracting objects close to the edges of the frame.

• Keep the composition simple.

I like to think of good composition as simply taking all of the elements that are before you, discarding the ones that detract from the story, and arranging the rest so that balance is achieved in the image. The most common mistake among less experienced photographers is including too much in their images. Fight the natural tendency to take in the whole scene. Force yourself to first identify and then concentrate on the portion of the overall scene that is of real interest. You may find yourself shooting with a medium telephoto lens a lot more often than with a wide-angle lens if you master this technique.

The concept of balance in a photograph is one that I cannot overemphasize. Choose a camera position that achieves balance among the major elements in your picture. For example, a strong center of interest in the upper right portion of the frame should be offset by elements of framing in the lower left.

Simplicity is another element of effective composition. Including just a few interesting objects, tastefully arranged, is always preferable to having too many items in the picture. You've likely heard some photographs described as "busy." This is a polite way of

The Sneffels Range in autumn, San Juan Mountains, Colorado. *Minolta 70–210mm lens, polarizing and enhancing filter, Fuji Velvia film.*

This pastoral scene in southwestern Colorado was photographed in a horizontal format to emphasize the feeling of restfulness and peace. The new snow on the peaks and the beautiful autumn color contribute strongly to the impact of the photograph.

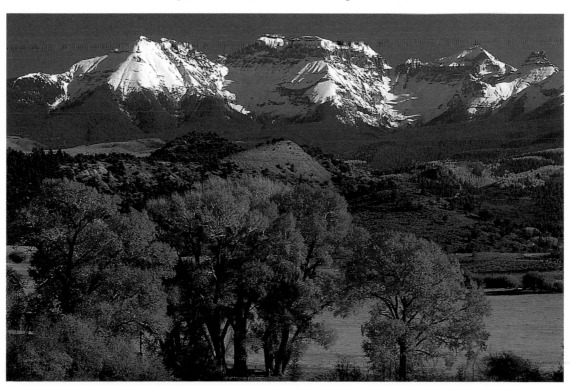

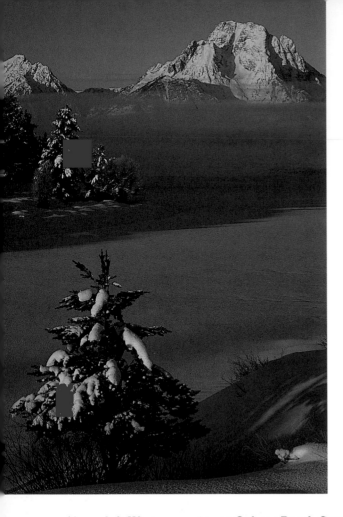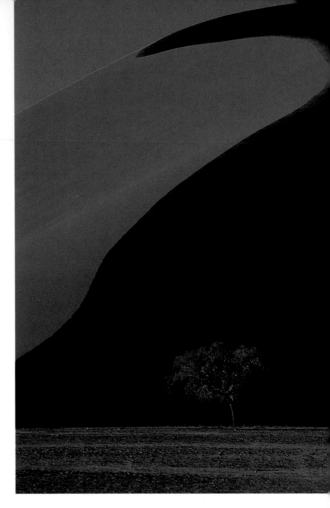

Above left: Winter sunrise at Oxbow Bend, Grand Teton National Park, Wyoming. *Minolta 35–70mm lens, polarizing and enhancing filters, Fuji Velvia film.*

The temperature was –20 degrees F, but I had no camera battery problems because I kept my camera inside my parka next to my body until the light was right to take the picture. The placement of Mount Moran in the upper right is balanced by the placement of the little tree in the lower left.

Above right: Dune pattern and acacia tree, Namib Desert National Park, Namibia. *Minolta 70–210mm lens, polarizing and enhancing filters, Fuji Velvia film.*

The Namib dunes, over 1,000 feet high and colored red by iron oxide, are among the most photogenic dunes in the world. On my first visit in 1987, I was impressed by the simplicity of this composition, with the lone acacia tree standing in front of the elegant dune pattern.

saying that the picture contains too many elements, and the composition, and therefore the message, is confusing. The eye tends to wander all around the picture instead of remaining in the area that the photographer intended.

I probably treat the sky differently than many other photographers. Unless the clouds are spectacular, I minimize the amount of sky in my photographs. My theory is that I want the viewer of my images to concentrate on the subject material contained

below the horizon and not be distracted by the sky above it. In most photographs, I include only enough sky to comfortably contain the elements on the horizon. I almost always polarize the image, which makes the small amount of sky that remains even darker and less distracting. If clouds are included, I prefer high cirrus or mare's tail clouds to the much brighter and more distracting cumulus clouds. I would rather have a well-polarized, bald sky than one that has too many clouds. If the sky is totally cloudy or milky, I attempt to eliminate it completely. This technique is easy when photographing into a canyon, but it's very difficult or impossible when pho-

tographing arches, spires, or peaks. On the other hand, if the clouds or sky is spectacular, I attempt to show a minimum of ground and a maximum of sky.

Be ruthless in your search for and elimination of elements that are distracting in your composition. Especially look for bright objects in the background and around the edges of the photograph. If distractions are identified in the background, either change your camera position slightly to avoid or hide them or, if this is impossible, remove or alter them. Distractions around the edges can be eliminated by cropping out the offending objects at the time of exposure. Eliminating the problem before taking

Balanced Rock and clouds, Arches National Park, Utah. *Minolta 35–70mm lens, polarizing and enhancing filters, Fuji Velvia film.*

The beautiful clouds inspired this photograph of Balanced Rock. The horizon was placed near the bottom of the frame to emphasize the sky. Because the clouds are wispy and not overly bright or heavy, they add beauty to the photograph and do not distract from the center of interest, Balanced Rock.

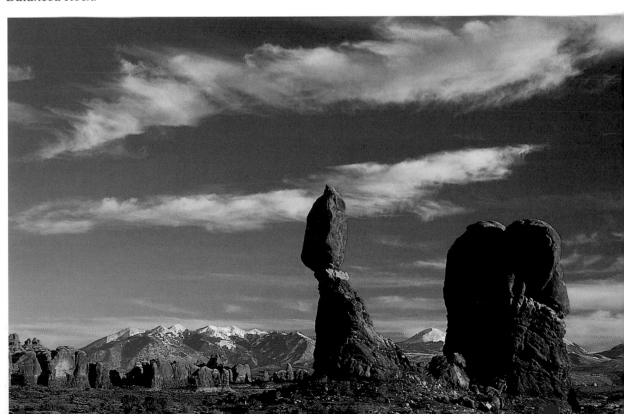

the photograph is far better than having to retouch or crop off the problem areas later.

I'm not a total purist when it comes to landscape photography. If I can't eliminate items such as bright rocks, leaves, weeds, or dead branches by cropping, I see no permanent harm to the environment in temporarily bending them out of the way or even removing them. I don't advocate picking flowers or harming any living bush or tree, but plucking a few blades of grass or moving a rock does no real or lasting damage.

Each photographer will and should develop his or her own individual style of composition. Though you may admire the images of other photographers, you will not be able to—and should not attempt to—copy their style. There will never be another Edward Weston, Ansel Adams, Freeman Patterson, or Joseph Muench. By developing your own style, you will maximize your own unique talents and provide a fresh insight into our natural world.

Center of Interest

The kind of artistic landscape photography that I advocate can be achieved only by evoking a strong emotional response from viewers. An essential element of this kind of image is a strong center of interest. The center of interest can be defined as the place in the photograph that the eye is drawn to and lingers. There should be no other objects of equal or nearly equal interest in the photograph to pull the eye away.

Death Valley dune pattern, Death Valley National Park, California. *Minolta 70–210mm lens, polarizing and enhancing filters, Fuji Velvia film.*

The curved lines of the dunes and the patterns of light and shadow inspired this image. A telephoto lens was used to concentrate on the most interesting portion of the overall scene. The area of maximum contrast was chosen for a center of interest and placed in the upper right portion of the frame.

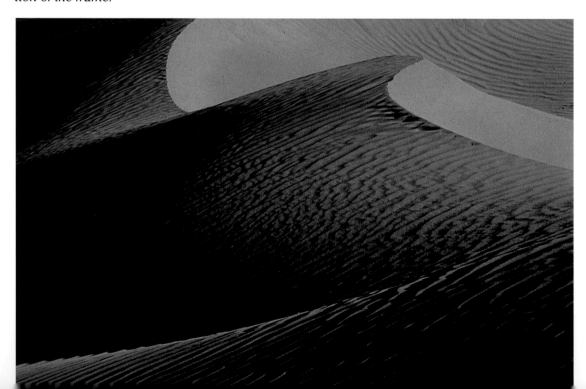

Most of all, the subject that is chosen as a center of interest should be interesting to a large number of people. Some subjects that may be of interest to the photographer may not have much interest to anyone else. If you want your image to be successful, choose a subject you believe will interest most people.

A wide range of subject material can be used successfully as the center of interest in a landscape photograph. Some of the most popular include mountain peaks; desert landforms such as arches, spires, and balanced rocks; sea stacks; flowers and trees; picturesque roads, barns, and houses; thermal features, such as those found at Yellowstone; the sun and moon; and waterfalls. The center of interest should stand out from the other objects in the picture because of its form, brightness, or color.

Ordinary objects seldom make strong centers of interest. The more dramatic the shape of the center of interest, the more exciting it will be to viewers, assuming that all the other elements of composition, lighting, and filtration are handled equally.

Where do you find the outstanding landforms that will provide strong centers of interest? Some may be found close to your home. The largest concentrations are found in the national and state parks and national monuments. These treasures were set aside because of their outstanding scenic features. A large percentage of my most successful images have been taken in these locations.

Another important consideration is the placement of the center of interest within the composition. Most of the time, I choose to place the center of interest somewhere other than in the center of the photograph. Exceptions to every guideline exist, however. Sometimes, when faced with a very symmetrical composition, I choose to emphasize this symmetry by putting the center of interest in the center of the picture.

The "rule of thirds" has been advocated for many years and certainly should be understood by all serious photographers. It states that if the image is divided into thirds both horizontally and vertically, the intersections of those lines are good places to

Pedestal rock, Zion National Park, Utah. *Minolta 35–70mm lens, polarizing and enhancing filter, Fuji Velvia film.*

This pedestal rock makes a strong center of interest because of its form and light color. This photograph was made near sunset when long shadows separated the rock from the background. For strong composition, the pedestal rock was placed in the upper right and balanced by the red rocks in the lower left.

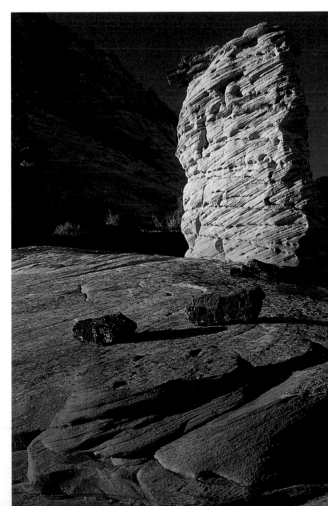

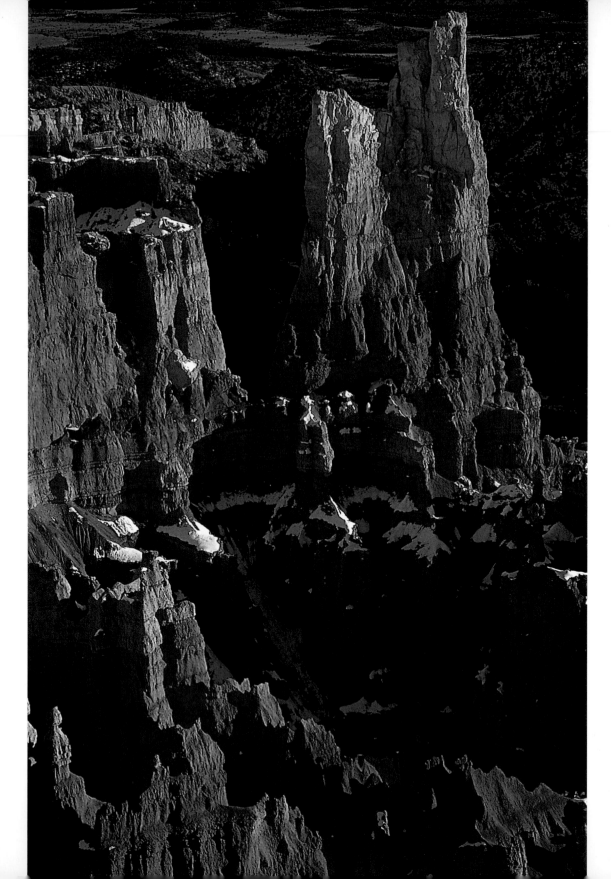

Spire at Paria Point, Bryce Canyon National Park, Utah. *Minolta 35–70mm lens, polarizing and enhancing filters, Fuji Velvia film.*

The form and color in Bryce Canyon National Park provide the ingredients for many outstanding compositions. The strong sidelighting gives wonderful texture to the rock. The camera position was chosen to place the spire against a dark part of the background.

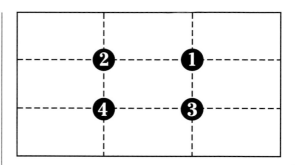

The rule of thirds, with Fred Kuehl's preferred locations for the center of interest.

put the center of interest. Numerous studies, past and present, indicate that placing the center of interest in one of these four locations is very effective. Placement according to the rule of thirds is not always possible or even desirable, but it should always be evaluated as a first option.

Fred Kuehl of Rock Island, Illinois, has theorized on which of these four locations in the frame provides the most effective placement for the center of interest. Fred believes that the upper right third is the strongest location for the center of interest, followed by the upper left, lower right, and lower left. Upon extensive reflection on and analysis of my own work, I have come to agree with him. Again, this approach should not be slavishly adhered to but should always be kept in mind.

In order to make the picture "read" better, photographers may be tempted to reverse an image for presentation, which can some-

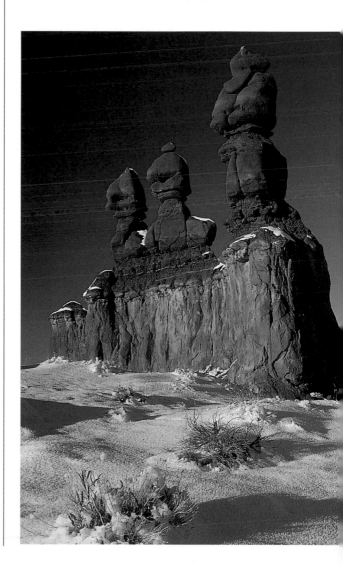

The Three Judges in winter, Goblin Valley State Park, Utah. *Minolta 35–70mm lens, polarizing and enhancing filters, Fuji Velvia film.*

The vertical lines of the rock formations give a feeling of strength and power to the photograph. Even though this picture was taken with a wide-angle lens, the goblins are large enough in the frame to provide a strong center of interest. This image was made near sunset after a rare snow in Goblin Valley.

times make it much stronger composition-ally. With wildlife, flowers, and general scenery, this technique can be desirable. However, when the photograph depicts well-known features such as the Grand Tetons, Maroon Bells in Colorado, or Half Dome in Yosemite, the fact that the image has been reversed will probably be recognized by a sizable number of viewers.

Another important consideration concerning the center of interest is its size. Many people have a tendency to include too much supporting material in a photograph. Using a wide- or ultra-wide-angle lens to record the image often renders the most important feature in the picture too small to be a strong center of interest.

The Use and Meaning of Lines

The proper use of lines in the composition can set the mood of the image and help tell the story. Always look carefully at the scene to determine whether any strong lines are present that can be included in your composition.

The orientation of a line determines its meaning. Horizontal lines convey peaceful-ness, rest, and tranquillity. If the mood you're attempting to create is pastoral, include as many horizontal lines as possible and use a

The Tetons and balsamroot, Grand Teton National Park, Wyoming. *Minolta 35–70mm lens, polarizing and enhancing filters, Fuji Velvia film.*

I chose a horizontal format for this photograph because I felt that this was a pastoral scene. A number of horizontal lines, including the line of the clouds, the line of the peaks, the upper and lower lines of the trees, and the line of the flowers, reinforced this interpretation.

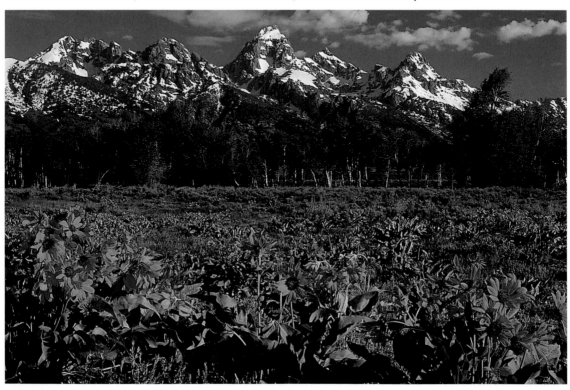

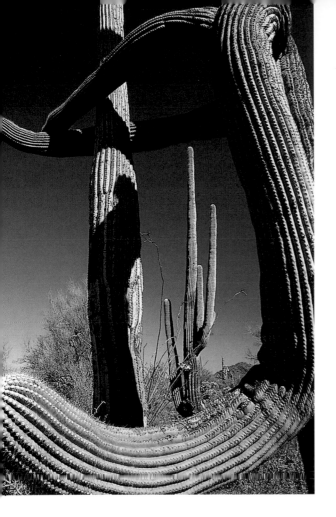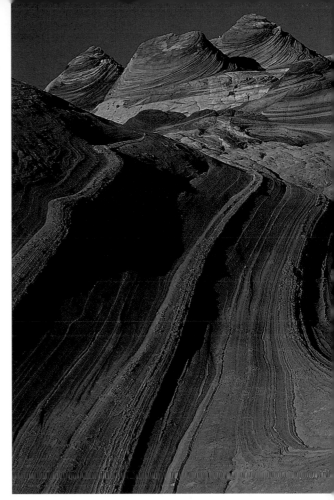

Above left: Saguaro patterns, Saguaro National Park, Arizona. *Minolta 24–35mm lens, polarizing and enhancing filters, Fuji Velvia film.*

The giant saguaro cacti, found in southern Arizona, are powerful vertical elements, whether they are used as main subjects or as framing material. Saguaro arms that bend down provide an interesting frame for mountains or other cacti. An extremely wide-angle lens was used to record this composition.

Above right: Rock patterns, Coyote Buttes, Paria River–Vermilion Cliffs Wilderness, Arizona. *Minolta 70–210mm lens, polarizing and enhancing filters, Fuji Velvia film.*

The ribs of hard sandstone provide both diagonals, which give action and motion to the picture, and leading lines, which take the viewer up to the buttes in the background. This picture has been reversed for presentation because it reads better from left to right.

horizontal format. Mesas, lakes, fences, clouds, ridges, fog, and pastures are typical subjects where horizontal lines predominate.

Vertical lines are lines of strength and power. The most often used verticals are trees, but other objects such as tall rocks, mountains, and large cacti can also be employed. Images with a predominance of strong vertical elements should always be photographed in a vertical format.

Diagonal lines are lines of action or motion. I am particularly fond of diagonals and emphasize them strongly in my workshops. Diagonal lines can be found in many subjects, but the slickrock country of Utah and Arizona provides some of the best examples. Joints in the rock and bedding patterns make wonderful diagonal lines. In close-up images of patterns with strong lines, such as ripples on a sand dune, choosing the orientation of these lines can be accomplished by adjusting the camera position. I almost always present them on a diagonal, usually leading from lower left to upper right.

Curved lines are lines of beauty, and it's desirable to include them in compositions whenever possible. Winding roads, sand dunes, rock walls, and fences are good examples of curved lines, and the slickrock areas of Utah and Arizona include many locations with an abundance of curved lines.

Pueblo Arroyo at sunset, Chaco Canyon National Historical Park, New Mexico. *Minolta 35–70mm lens, polarizing and enhancing filters, Fuji Velvia film.*

This composition, with the curved lines leading up to the pueblo in the background, is one of my favorites. I chose my camera position carefully to take full advantage of the curved lines and photographed the scene at sunset to add more color to the rock and make the curved wall stand out even more.

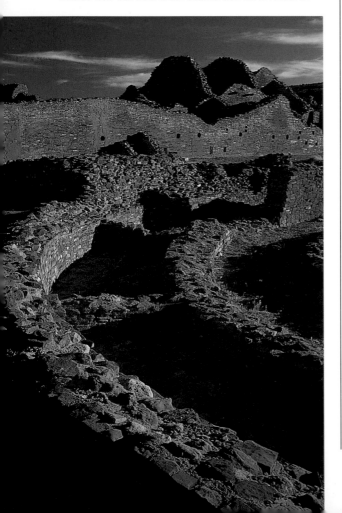

The Factors That Control Composition

Two factors—and only two factors—control composition. The first is camera position, and the second is the focal length of the lens. Sometimes a considerable amount of time and effort is necessary to determine the optimum camera position for a composition; on other occasions the decision is quite easy. Many times I can visualize my exact composition from 100 yards away. Other times I spend quite a while searching but can't find the elements of composition that I require, so I don't take the photograph. Sometimes the camera position is so critical that the movement of 1 inch in any direction will adversely

Kokerboom Forest, Keetmanshoop, Namibia. *Minolta 35–70mm lens, polarizing and enhancing filters, Fuji Velvia film.*

When composing a scene with multiple subjects, I try to choose a camera position where none of the elements overlap or are cut off by the edges of the frame. One of the objects should dominate in size, color, or form. At this location, moving a foot in any direction would have caused overlaps or amputations in the composition.

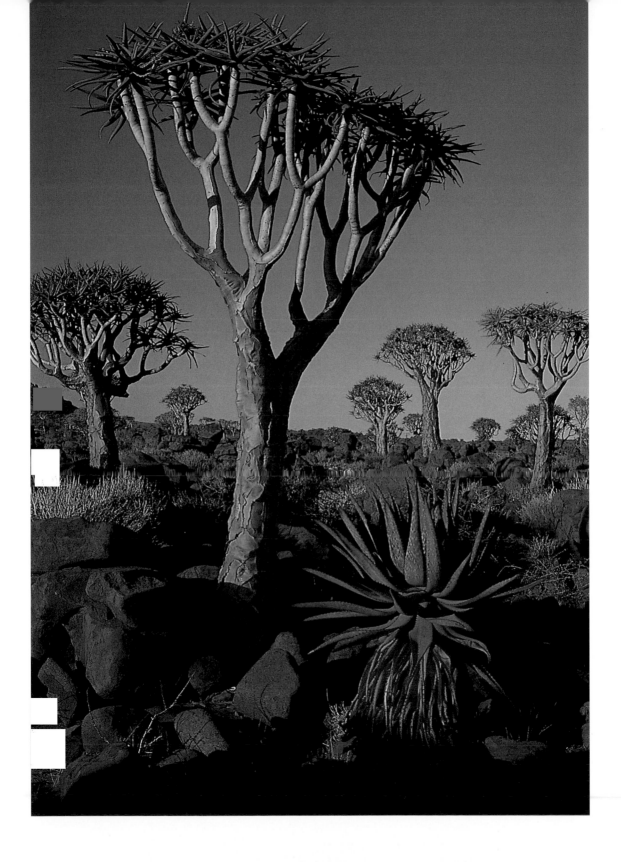

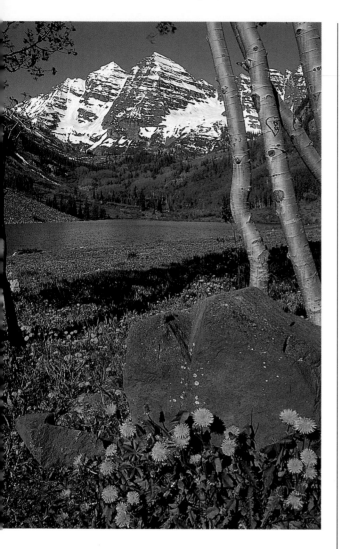

The Maroon Bells in springtime, White River National Forest, Colorado. *Minolta 35–70mm lens, polarizing and enhancing filters, Fuji Velvia film.*

The Maroon Bells, near Aspen, are surrounded by dandelion-covered meadows. A wide-angle lens enabled me to include important elements of framing, such as the aspen trees, rocks, and dandelions. Setting the aperture at f/22 and focusing at the hyperfocal distance allowed me to obtain sharp focus throughout.

affect the composition, and other times the camera position can be moved 50 yards without any compositional consequence.

Camera position is defined not only by location on the ground, but also by the height of the camera. Frequently it's important or even critical for the camera to be high enough to shoot over some foreground obstruction or to achieve a particular framing. I am fortunate to be quite tall, which usually helps me attain the high camera position that I need. Shorter individuals may need to stand on rocks, logs, or fences. Low camera positions are also necessary at times. On rare occasions I've had to lie flat on my back or stomach to achieve the proper perspective.

The other factor in attaining the desired composition is choosing the proper focal length of lens. I use only zoom lenses for my landscape photography so that I can frame my composition exactly the way I visualize it. The use of fixed focal-length lenses forces the photographer to fit each composition into different fixed frames. The principal complaint about zoom lenses twenty years ago was that they were not as sharp or as well color corrected as fixed focal-length lenses. That may have been true then, but computer design of the optics and improved coatings have brought zoom lenses to the point that only microscopic differences in quality, if any, separate them from fixed focal-length lenses.

I use wide-angle lenses (in the 17 to 45mm range) primarily to emphasize interesting foreground. Normally I choose a vertical format with wide-angle lenses. This allows me to compose background elements in the upper part of the frame and foreground elements in the lower part of the frame. The proportions may vary depending on the subject material, but normally I allow about two-thirds of the frame for the foreground and one-third for the background.

One of the physical characteristics of wide-angle lenses is their ability to achieve much greater depth of field at a given aper-

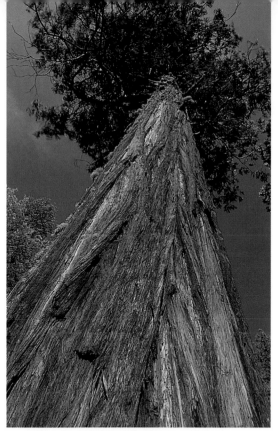

Redwood tree in Yosemite, Yosemite National Park, California. *Minolta 24–35mm lens, polarizing and enhancing filters, Fuji Velvia film.*

To photograph this beautiful redwood tree, I set up my camera close to the trunk, used a very wide-angle lens, and pointed almost straight up along the trunk. I chose to put the trunk on a slight diagonal and took advantage of the vertical exaggeration to accentuate the height of the tree.

Horseshoe Bend, Colorado River, near Page, Arizona. *Vivitar 17–28mm lens, polarizing and enhancing filters, Fuji Velvia film.*

Upon visiting this awe-inspiring view for the first time several years ago, I realized that the widest lens in my arsenal, a 24–35mm, was not wide enough to include the whole bend and the banks on all sides of the river. A lens of at least 20mm is needed to accomplish this. Accordingly, I purchased an inexpensive Vivitar 17–28mm lens specifically to record this image.

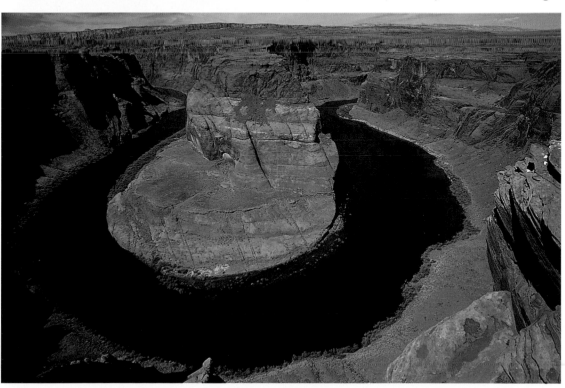

ture than normal or telephoto lenses. This allows the photographer to obtain sharp focus on foreground objects such as flowers or rocks and at the same time achieve sharpness at infinity.

Extreme care must be taken when using wide-angle lenses with trees to avoid the appearance of vertical convergence. Although rocks or mountains may also be distorted by wide-angle lenses, this distortion is usually not obvious. Sometimes the vertical exaggeration created by wide-angle lenses can be intentionally employed to create a powerful image.

When I shoot a wide-angle lens horizontally, it's usually to include a wider vista in the photograph. I do this only sparingly, because it is easy to weaken a good composition by including too much. However, for some subjects, it is mandatory.

When photographed with a normal lens (45 to 70mm), foreground and background objects have about the same relationship to each other as our eyes see them. Normal lenses do not accentuate the foreground as much as wide-angle lenses or pull in the background like telephoto lenses. They allow a moderate amount of depth of field.

Telephoto lenses (70 to 800mm) can be used for two distinctly different purposes. One use is to concentrate on the most dramatic portion of a scene. In this type of image, very little or no foreground material is included, although compositional concepts such as balance and placement of the center of interest still apply.

The other use of telephoto lenses is to change the relationship of the size of a closer object to that of a more distant object. The stronger the lens, the greater

Namib dune pattern at sunset, Namib Desert National Park, Namibia. *Tamron 200–400mm lens, polarizing and enhancing filters, Fuji Velvia film.*

The gravel road that leads up the valley between the gigantic red dunes of the Namib Desert is often a half mile from the base of the dunes. A long lens is needed to capture the striking patterns that occur within an hour of sunrise and sunset on the dunes. This image was shot at 400mm.

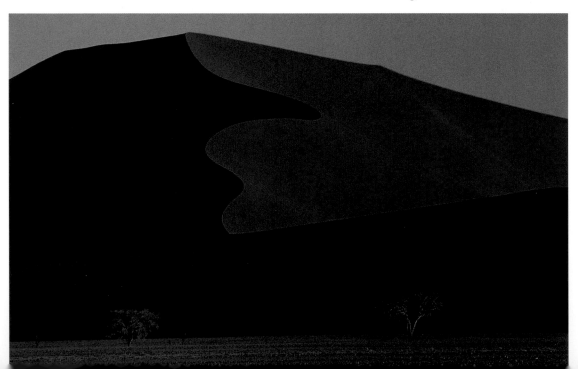

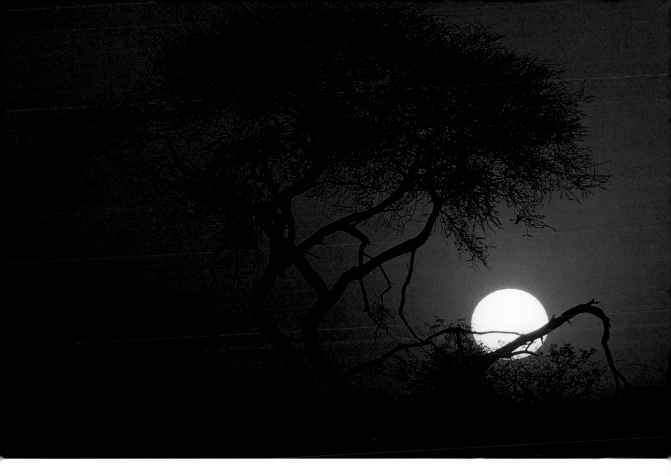

Sunset at Etosha, Etosha National Park, Namibia. *Canon 150–600mm L lens, no filters, Kodachrome 64 film.*

In Africa, haze and dust in the air frequently diffuse the sun enough to eliminate lens flare. The graceful acacia trees, when combined with the sun, make striking images. I used a 600mm lens and chose an acacia tree that was about 100 yards away so that, even with the limited depth of field of a 600mm lens, the tree and sun would both be in sharp focus.

this change in perspective. One of the inherent characteristics of telephoto lenses is a much shallower depth of field at a given aperture than that of a normal or wide-angle lens. To overcome this problem, foreground objects must be placed farther from the lens, and a smaller aperture, such as f/22 or f/32, should be used.

Framing and Depth of Field

Good landscape photographs usually give a feeling of depth. Our eyes, because of the distance between them, give a slightly different

view of each scene. These slightly different perspectives give us a perception of depth. Stereo photography, where two images are taken simultaneously several inches apart, can re-create this effect. Stereo photography is not as popular as it once was, but used Stereo Realist and Kodak stereo cameras, with two lenses mounted 4 inches apart, can still be obtained. Images taken simultaneously with two single-lens reflex cameras with identical lenses can produce the same results. When used properly, stereo photography can yield some striking images.

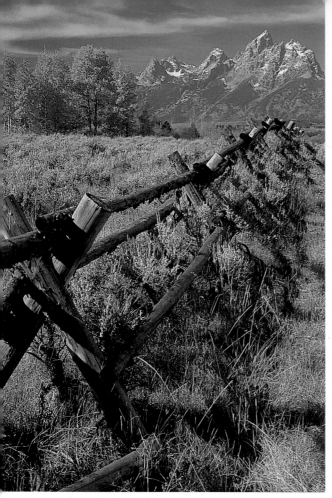

Although most photographers today record images that are only two-dimensional, the proper use of framing can give a three-dimensional quality to the images. A complete range of material from near to far gives the best impression of depth. One of the most recognizable elements of the personal style I've developed over the years is

Tetons and fence in autumn, Grand Teton National Park, Wyoming. *Minolta 35–70mm and 70–210mm lenses, polarizing and enhancing filters, Fuji Velvia film.*

This pair of photographs shows that composition and mood can be determined by the choice of lens and the camera position. In the vertical shot, taken at 35mm, the fence provides a strong diagonal that gives a feeling of action and motion. The horizontal picture, taken at 70mm from a camera position only 10 feet away, emphasizes the pastoral qualities of the scene. The diagonal of the fence, though not as strong as in the vertical image, still provides some feeling of motion.

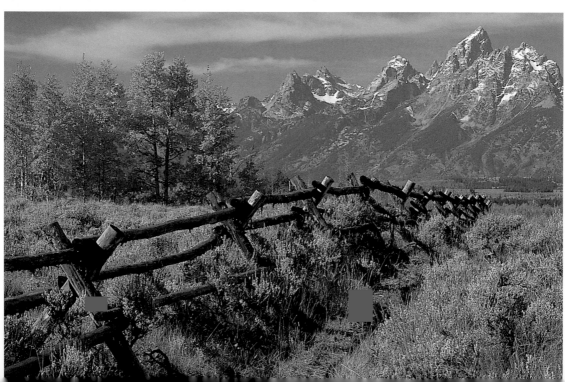

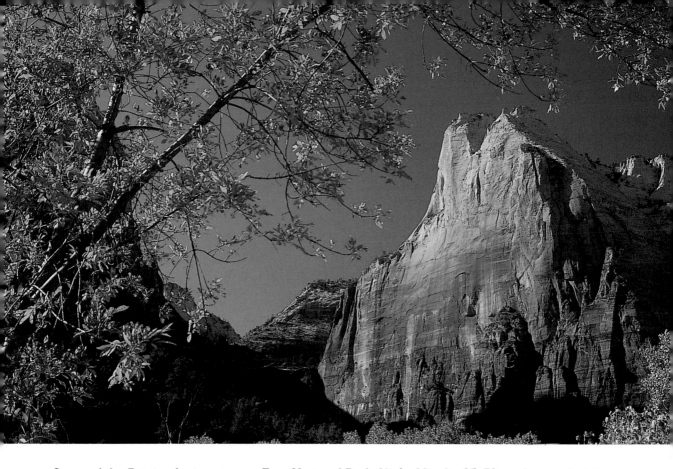

Court of the Patriarchs in autumn, Zion National Park, Utah. *Minolta 35–70mm lens, polarizing and enhancing filters, Fuji Velvia film.*

Trees and foliage are the most often used elements of framing. In this image, the tree provides a feeling of depth and covers up an area of bald sky. The diagonal tree limbs impart action and motion to the picture. Finally, the brilliant autumn foliage helps tell the story about the time of year and adds color and vibrancy.

the effective use of interesting framing material. I spend a lot of time looking for good elements of framing to incorporate into my photographs.

To contribute positively to the overall image, framing material should be in sharp focus, be interesting in color and shape, provide balance to the composition, help tell the story, and not overpower the center of interest. Trees are probably the most often used elements of framing. Perhaps my favorites are the gnarled junipers found in the canyon country and the aspen trees found throughout the Rocky Mountains.

Naturally occurring features such as rocks, flowers, grasses, and bushes, as well as man-made objects like fences and gates, may also be used effectively for framing.

I believe strongly that all of the elements of landscape photographs should be in sharp focus. Fuzzy, out-of-focus framing detracts from the image. Both near and far objects can be rendered in sharp focus by the proper use of depth of field.

Wide-angle lenses have the capability of greater depth of field than that of normal or telephoto lenses. Smaller apertures such as f/22 or f/32 yield more depth of field, at a

given focal length, than do f/8 or f/11. Each composition must be analyzed individually to determine how much depth of field is necessary. If all elements are essentially at infinity, very little depth of field is required, and f/5.6 or f/8 may be an appropriate aperture. If foreground elements are very close to the camera, however, even the smallest aperture may not yield the depth of field needed, and the camera position may have

Below left: Angel Arch and the Dentist's Delight, Canyonlands National Park, Utah. *Minolta 35–70mm lens, polarizing and enhancing filters, Fuji Velvia film.*

 Rocks can also make good framing devices. In this photograph, the Dentist's Delight is very interesting and prominent in its own right, and it could be argued that the rock competes for attention with the intended center of interest—the arch. My eye still goes to the arch because of its lighter color and form.

Below right: Spring wildflowers in Namaqualand, Cape Province, Republic of South Africa. *Minolta 35–70mm lens, polarizing and enhancing filters, Fuji Velvia film.*

 To achieve sharp focus on the flowers in the foreground and the distant objects simultaneously, I used f/22 and set my distance scale for the hyperfocal distance, 7 feet, which provided a depth of sharp focus from 3¹/₂ feet to infinity. The composition is aided greatly by having a center of interest, the old building.

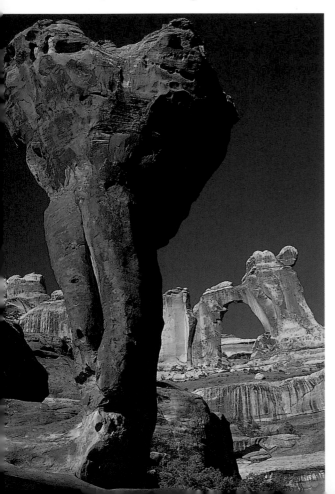

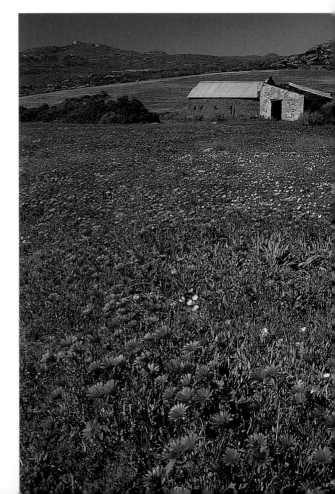

Orb weaver spider pattern, Fort Myers, Florida. *Minolta 70–210mm lens, close-up lens, no filters, Kodachrome 200 film.*

Sometimes limited depth of field is appropriate. In this photograph, I wanted to render the dew-covered web sharp but keep the background soft. To accomplish this, I chose f/11 for the aperture. The radial lines and the placement of the center of interest in the upper right third make this a powerful composition.

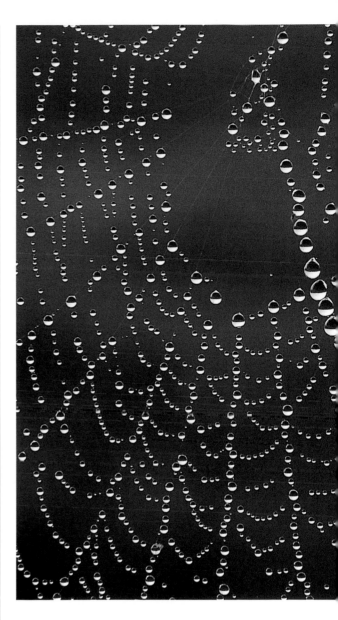

to be moved farther away from the nearest object to achieve sharpness.

To determine the required depth of field, the concept of hyperfocal distance must be understood and correctly applied. The hyperfocal distance for a particular shot is that distance which, at a given focal length and aperture, gives the greatest amount of sharp focus. (The distance is based on a mathematical formula using assumptions about the degree of sharpness required. Knowing the formula and its derivation is of academic value only and is not needed to properly use and understand hyperfocal distance.) When the hyperfocal distance is set on a lens, the depth of field extends from half the hyperfocal distance to infinity. Knowing this distance is critical, especially in scenic photography.

In past years, most lenses, even zoom lenses, had depth-of-field scales inscribed on their barrels. These scales made hyperfocal distance relatively easy to understand, explain, and set for each photograph. But with the introduction of autofocus cameras, manufacturers have dropped the depth-of-field scales on most lenses. Some have even eliminated distance scales from their lenses, which makes it virtually impossible to set the depth of field, even manually. This is one reason that I still use older, manual-focus lenses that have depth-of-field scales inscribed on their barrels for my landscape photography.

The concept of hyperfocal distance and how to use it is very confusing to many students. Once they've set the hyperfocal distance on the lens, they frequently observe that neither foreground nor background looks sharp. This is because the camera lens is wide open (with a very narrow depth

of field) when composing the image; it stops down to the taking aperture only at the moment of exposure. If your camera features a depth-of-field preview button, you can attempt to determine whether all of the elements in the picture are sharp. But when the lens is stopped down to f/22 or f/32, the overall image may be so dark that determining whether the near and far objects are in critical focus may be difficult or impossible.

Canon has incorporated a depth-of-field program in its EOS cameras. This takes the near and far points in the image and calculates the aperture and sets the hyperfocal distance needed to accomplish sharp focus throughout this range. However, I still prefer setting the hyperfocal distance manually.

Since proper use of depth of field is such an important consideration in landscape photography, charts have been derived so that photographers who do not have the information on their lens barrels can properly set the hyperfocal distance. One of the best, a small, plastic card with a wide range of apertures and focal lengths, was calculated by Steve Traudt and can be purchased for a modest price from Synergistic Visions, Box 2585, Grand Junction, CO 81502, telephone/fax (970) 245-6700, e-mail: synvis@gj.net.

I've also compiled a set of hyperfocal distances using booklets supplied by lens manufacturers. We furnish this table to all of our workshop participants so that they will be able to correctly use hyperfocal distance in the field.

These numbers assume that infinity is the far distance. For focal lengths other than those given, simply interpolate. For focal

Namib dune and stump, Namib Desert National Park, Namibia. *Canon 100–300mm L lens, polarizing and enhancing filters, Fuji Velvia film.*

The use of hyperfocal distance, to achieve maximum depth of field, is important with telephoto lenses as well as wide-angle lenses. To make the dune appear larger in relation to the tree, I backed off from the stump and used a 300mm lens. The depth program on my Canon EOS computed the proper aperture and hyperfocal distance needed to obtain sharpness throughout the photograph.

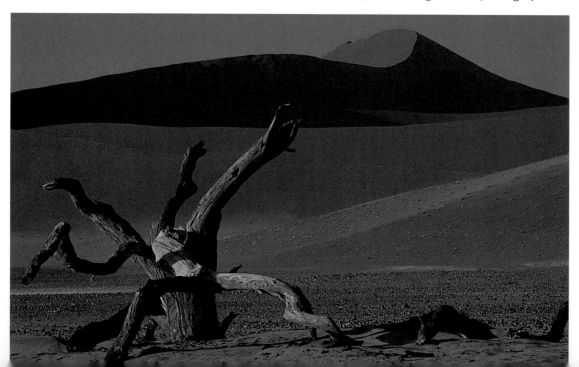

Lens (mm)	20	24	28	35	50	70	100	135	200
Hyperfocal Distance (in Feet)									
f/16	3.2	4.7	6.3	10	20	35	80	–	–
f/22	2.3	3.3	4.5	7	14	28	55	90	200

lengths greater than 200mm, the depth of field is very small. A good rule of thumb is to use the minimum aperture of the lens (usually f/32) and focus somewhere between the nearest and farthest objects you want in focus.

Since the use of hyperfocal distance is somewhat confusing, an example might help to clarify this important concept. Assume you want to shoot a scene such as that on the cover of this book that includes distant mountains, a pond in the foreground, and grass and underwater rocks very close to the camera position. Let us also assume that to include the desired amount of peaks and framing in the background, you need a 50mm lens and that this lens has a minimum aperture of f/22.

The chart tells us that the hyperfocal distance for a 50mm lens at f/22 is 14 feet. Since the nearest sharp focus is half of the hyperfocal distance (in this example, 7 feet), everything from 7 feet to infinity will be in sharp focus when the distance on the lens barrel is set for 14 feet. This means that you must place the camera at least 7 feet from the nearest object (in this case, the grass) in the foreground.

Fisher Towers at sunset, Castle Valley, Utah. *Minolta 35–70mm lens, polarizing and enhancing filters, Fuji Velvia film.*

This photograph has great impact because of the color and shape of the rocks. Sunset light was used to render the rocks as red as possible. Warm colors have more impact than cool colors and convey a feeling of happiness and joy.

Impact

Impact is an ingredient found in many great photographs. It is the quality that grabs the viewer's attention and evokes an immediate strong, positive reaction. Impact may be generated by an extremely compelling subject, dramatic lighting, an unusually powerful angle, or a combination of the above.

Some worthwhile photographs have very little impact, however. If you spend a sufficient amount of time studying a subtle image, the photograph may grow on you. While impact is one of the desirable attributes in a landscape photograph, sound composition, lighting, balance, simplicity, and mood are equally important qualities if the image is to stand the test of time.

Putting It All Together

One of the most popular features of the workshops we conduct is the explanation of the thought process involved in putting all of these techniques together to create a memorable image. The process starts by identifying a center of interest that will affect the average viewer in a positive way. You should also look for the general camera position from which the center of interest can be photographed from the most attractive angle.

The next decision concerns the mood you'd like the picture to impart. Usually this is dictated by the subject material chosen for the image, but it's also dependent on the quality and direction of the light falling on the scene. For a pastoral scene you should choose a horizontal format and look for horizontal lines to include in the picture. If the subject suggests more dramatic treatment, a vertical format should be chosen and as many vertical lines as possible incorporated. Diagonal or curved lines, if present, will benefit either treatment.

Next, you must decide the approximate focal length of the lens to be used. This decision will be based on the size that is chosen for the center of interest, and how much supporting material is to be included around it. Then you should search the immediate area for foreground elements, if needed, that will balance and complement the center of interest, help tell the story, and provide a three-dimensional feeling. If possible, some elements in the middle dis-

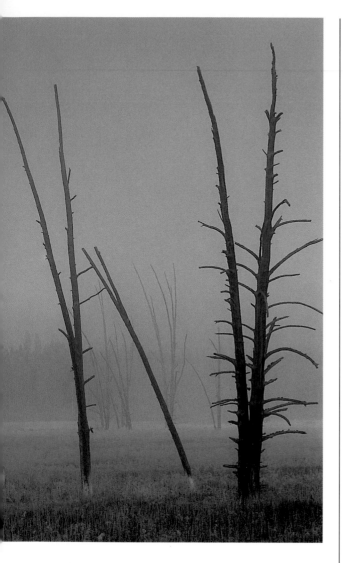

Dead trees in fog, Yellowstone National Park, Wyoming. *Minolta 70–210mm lens, no filters, Fuji Velvia film.*

This image is subtle and takes some time to study and appreciate. The cool colors, along with the dead trees, help establish a mood of quiet and calm. A vertical format was chosen for this picture because of the predominance of vertical material in the frame. The leaning tree in the foreground provides some motion.

tance should also be included to provide a continuous range of depths.

At this juncture, you should choose the final camera position and height and place the camera on a tripod. Closely scrutinize the frame to identify and eliminate distractions, mergers, and amputations. Final adjustments can be made to the cropping using the zoom lens. The filters that you deem appropriate should now be placed on the lens, and if a polarizing filter is used, rotate it to the proper orientation.

Next, measure the light falling on the scene (discussed in part 3) and decide upon a median exposure. Since a combination of the shutter speed and aperture determines the exposure, the specific needs of each image must be evaluated. Does the photograph demand maximum depth of field? If so, the picture must be taken at the minimum aperture of the lens at whatever shutter speed provides the right exposure. Will the breeze move grass, flowers, and leaves? If so, the shutter speed should be increased and a larger aperture used, as long as the reduced depth of field is still adequate to render everything in the photograph in sharp focus. If maximum depth of field and maximum shutter speed are both needed, patience and luck are required to capture the scene at a moment when the wind dies down. If the scene requires neither great depth of field nor great shutter speed, an aperture such as f/11, being in the middle of the aperture range, supposedly gives marginally sharper pictures.

Finally, set the combination of shutter speed and aperture that you decided upon, adjust the depth of field and readjust the position of the polarizer if necessary. If the scene is backlighted, the lens should be shaded. At this point, the final exposure can be made. If all these steps have been accomplished successfully, the resulting image will be artistically and technically rewarding.

Courthouse Rocks, Red Rock Crossing, Sedona, Arizona. *Minolta 35–70mm lens, polarizing and enhancing filters, Fuji Velvia film.*

The camera position, on a rock along the edge of the stream, was somewhat precarious. However, it was the only vantage point that allowed me to avoid the trees and branches to the left and include the beautiful curving line of rocks and riffles in the foreground.

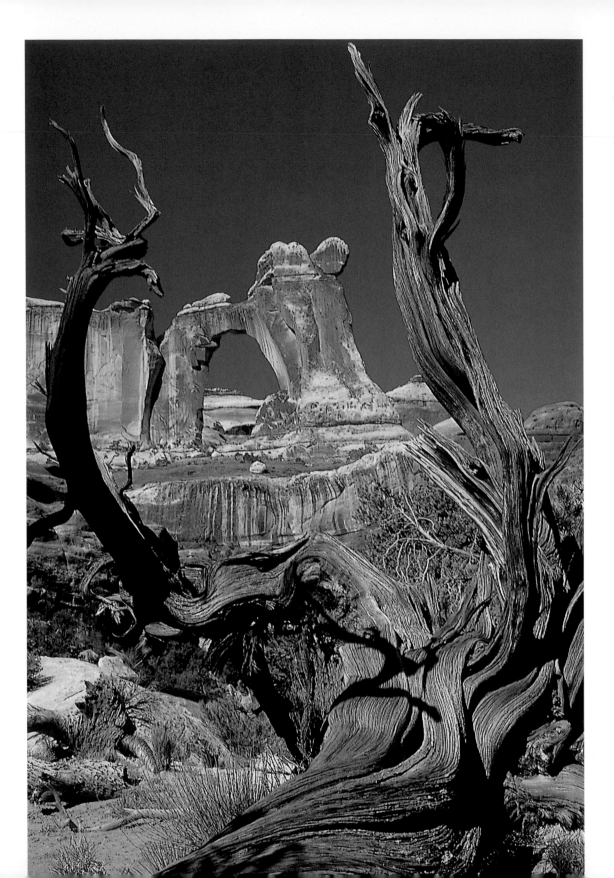

Angel Arch and juniper, Canyonlands National Park, Utah. *Minolta 35–70mm lens, polarizing and enhancing filters, Fuji Velvia film.*

When an exciting center of interest has been identified, it's usually productive to search for other interesting compositions in the immediate area. At this location, I shot four excellent images involving Angel Arch— one on each side of the Dentist's Delight, shown previously, and two others involving the juniper tree in this photo.

Once the slide or negative has been processed, evaluation may suggest the need for additional cropping to eliminate distractions, for changes in composition, or for changes in the shape of the final pre-sentation. Not all images should exhibit the 24x36mm proportions that most single-lens reflex cameras produce. Some compositions may be most effective in a square format or a long, narrow format. Cropping prints to attain different shapes is simple; only a scissors is required. The proportions of slides can be changed by the use of cropping masks or mounts. Both masks (to be used between cover glass) and cardboard heat seal mounts in eight different opening sizes can be obtained from Erie Color Slide Club, P.O. Box 672, Erie, PA 16512-0672, telephone (814) 456-7578. I have used their products for many years with excellent results. Several other companies market plastic mounts containing glass inserts with a number of different opening sizes.

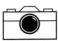

Lighting

General Principles

Effective lighting is the other key ingredient in any memorable image. Any outstanding photograph must have not only interesting subject material and good composition, but also excellent lighting. The best of compositions, without the proper lighting, have little interest or impact. Outstanding lighting may transform an average scene into a memorable image.

Imagine a scene in the red-rock country with rock formations and interesting lines in the foreground leading up to a photogenic arch in the background. With warm early or late light at the proper direction, the colors will be beautiful and the arch and foreground rocks will have excellent texture. If the day is cloudy or the photograph is taken during the middle of the day, the wonderful colors and textures will disappear, and the image will be mediocre at best.

The proper light, however, is not always bright sunlight. If the image is taken in a forest, a cloudy day is usually preferable. On a sunny day, the wide range of light values makes properly exposing sunlit and deeply shaded areas impossible. On a cloudy day, there is a smaller range of light values, and a successful photograph can be made.

I've found over the years that if the light is not adequate in quality, quantity, or direction, any photograph taken will almost cer-

tainly be discarded by a discerning photographer. Accordingly, whether I'm photographing on my own or leading a workshop, I'm usually not in the field during the middle of the day or at times when the lighting is too poor to obtain a good image. Individuals who choose to photograph when the lighting is poor are just wasting time, energy, and film.

Photographers should have the flexibility, however, to adjust their targets if conditions warrant. In the mountains, cloudy weather may preclude good scenic photography but provide ideal conditions for photographing wildflowers or other close-ups. In Olympic National Park, sunny skies make photographing in the rain forest difficult but provide ideal conditions for images at the seacoast or on Hurricane Ridge. Very few scenic photographs in the red-rock country and the desert Southwest are successful without strong sunlight, but cliff dwellings and rock art may benefit from the more even lighting of an overcast day.

Directions of Lighting

Frontlighting is what many individuals use at the beginning of their photographic careers. Frontlighting falls evenly on the subject and minimizes shadows; however, it tends to produce flat, uninteresting photographs. I rarely photograph landscapes with frontlighting.

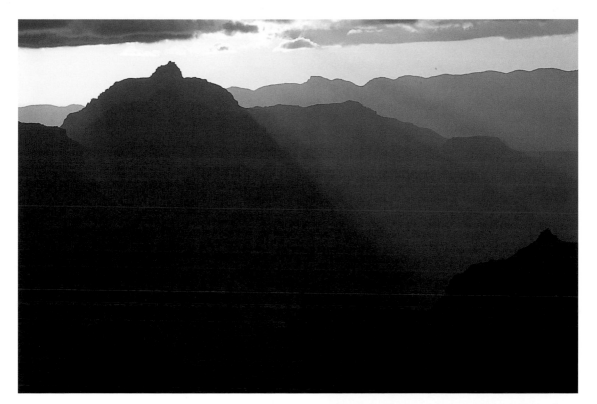

Grand Canyon at sunrise, Grand Canyon National Park, Arizona. *Minolta 70–210mm lens, enhancing filter, Fuji Velvia film.*

Spectacular lighting can make the difference between a mediocre photograph and an outstanding one. The atmospheric haze in the canyon was instrumental in making the diagonal rays of the sun prominent. The clouds above the horizon shadowed the camera lens and prevented flare.

Granite monoliths—White Tanks, Joshua Tree National Park, California. *Minolta 35–70mm lens, polarizing and enhancing filters, Fuji Velvia film.*

I have often thought that the shapes of the granite monoliths and boulders in Joshua Tree National Park are more interesting than the Joshua trees themselves. The strong sidelighting on these rocks about an hour before sunset provides both the quality and direction of light needed to successfully define the shape of the rocks.

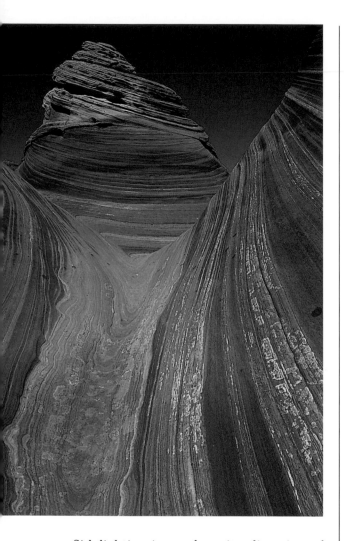

Sidelighting is my favorite direction of illumination for landscape photography. It emphasizes the texture of objects in the picture and gives the viewer a real feel of the shape of these objects. Strong sidelighting also allows maximum polarization, which influences all of the colors in the photograph in a positive way. I usually plan to visit previously identified compositions at a time of year when I can expect strong sidelighting within an hour or two of sunrise or sunset. It's impossible to go to an area just once and return with well-lighted photographs of all of its features.

Coyote Buttes Pattern, Paria River–Vermilion Cliffs Wilderness, Arizona. *Minolta 24–35mm lens, polarizing and enhancing filters, Fuji Velvia film.*

This is one of only a handful of landscapes that I've photographed with frontlighting. I reluctantly did so because the narrow trough between the rocks would have been very dark with sidelighting. Despite the frontlighting, the rocks, because of the different-colored strata, still appear to have texture.

Backlighting can be very dramatic. Backlighting simplifies composition by eliminating most of the details from objects in the picture. The elements that remain—forms and tones—can usually be easily arranged. Plants that have needles, such as cactus and cholla, are especially interesting because backlighting produces a halolike effect. Autumn leaves are most colorful with backlighting or strong sidelighting.

Care must be taken with backlighting to ensure that direct sunlight does not strike the lens and cause lens flare. Lens flare refers to the reduction of quality and contrast in the image when a strong source of light shines directly on the lens. It produces the little hexagons that are so objectionable in a quality photograph. These effects are most noticeable with lenses that have multiple elements and especially zoom lenses.

The Queen's Garden from Sunrise Point, Bryce Canyon National Park, Utah. *Minolta 35–70mm lens, polarizing and enhancing filters, Fuji Velvia film.*

This photograph demonstrates strong, low sidelighting—my favorite lighting situation. The colors and texture are wonderful. The other key ingredients were the filters and the film. In winter, snow adds additional sparkle and contrast to pictures in the red-rock country.

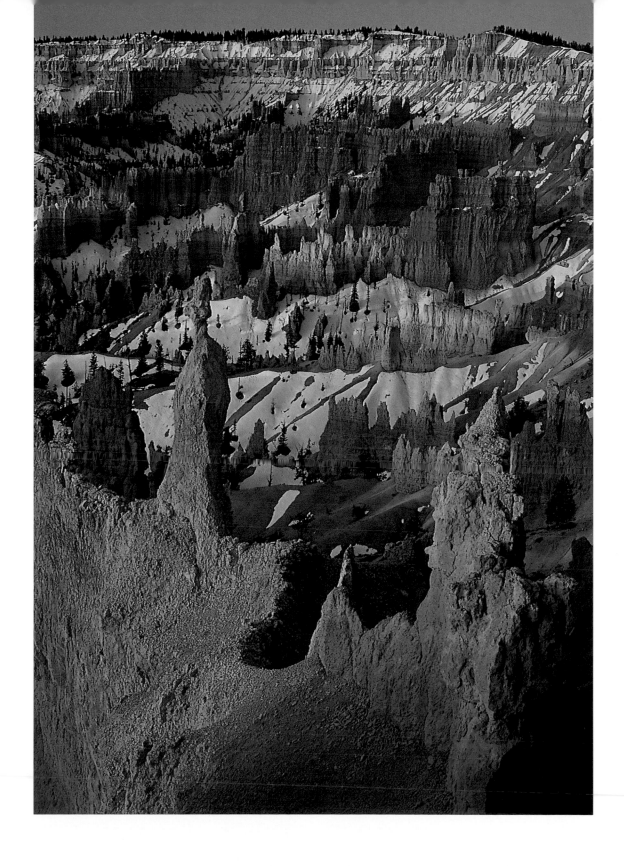

Lens flare can be prevented in backlighting situations by either using a restrictive lens hood or shading the lens with your hand. Lens hoods for zoom lenses must be wide enough not to vignette at the widest focal lengths; therefore, they don't protect very well at the more telephoto end of the zoom range. I prefer to stand alongside the camera and shade the lens with a hand or hat so that I can see when the lens is properly shaded.

At times, when the sun is very close to the field of view, it may be impossible to shade the lens without violating the frame.

Indirect lighting occurs on overcast days, when photographing in heavily shaded areas, or before sunrise and after sunset. This is the most favorable light for forest scenes or for other high-contrast subjects.

I especially like the photographic effects that can be obtained during the alpenglow

Stronghold House, Hovenweep National Monument, Utah. *Minolta 35–70 mm lens, polarizing and enhancing filters, Fuji Velvia film.*

This pair of photographs illustrates the difference between frontlighting and sidelighting. The left-hand picture was taken near sunrise and has good-quality light but is very flat. I returned about three hours later and took the right-hand photograph, which has excellent texture. Although the light is not as warm, I prefer the photograph with sidelighting.

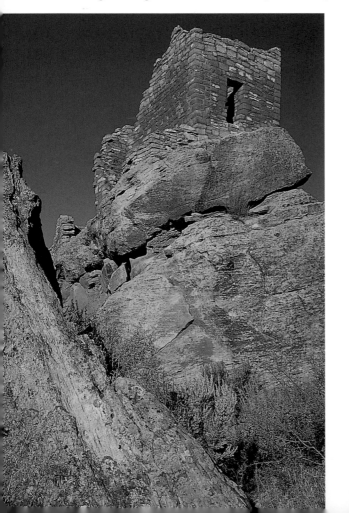
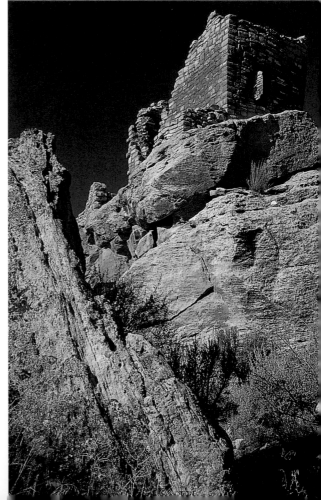

periods before sunrise or after sunset. With the very long exposures needed at these times of low light, some unusual and breathtaking photographs can be made. This is

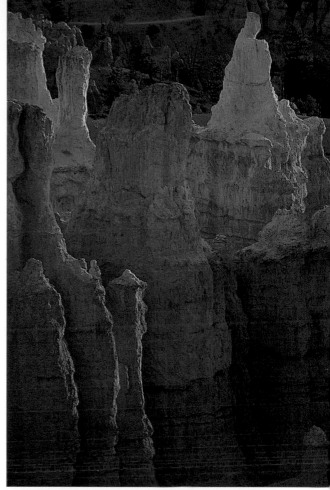

Backlit spire—Navajo Loop, Bryce Canyon National Park, Utah. *Minolta 70–210mm lens, enhancing filter, Fuji Velvia film.*

Backlighting is especially effective when light rocks bounce light back into the shadow areas. The rocks work like a reflector does in portraiture. This kind of lighting produces an almost incandescent effect. The lens was shaded to prevent lens flare.

Hoh Rain Forest patterns, Olympic National Park, Washington. *Minolta 70–210mm lens, no filters, Fuji Velvia film.*

This image was photographed on a completely cloudy day, perfect for a forest scene. I used a short telephoto lens to concentrate on the strong patterns of these branches. Velvia film, with no filtration, has a slight greenish cast and is ideally suited for photographs in the rain forest.

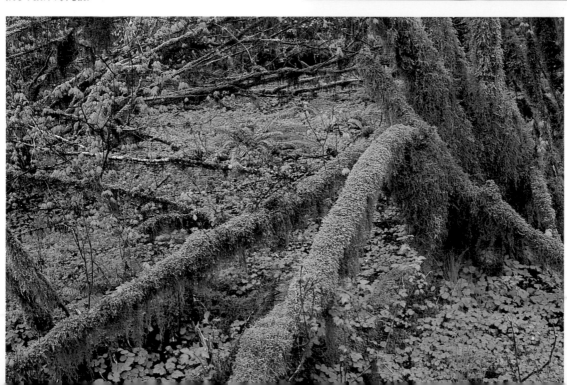

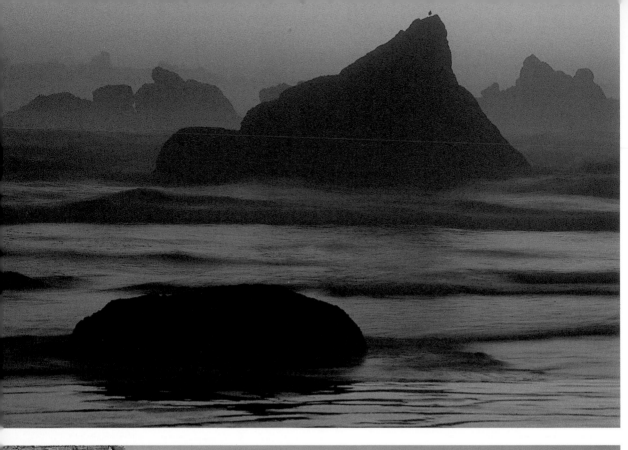

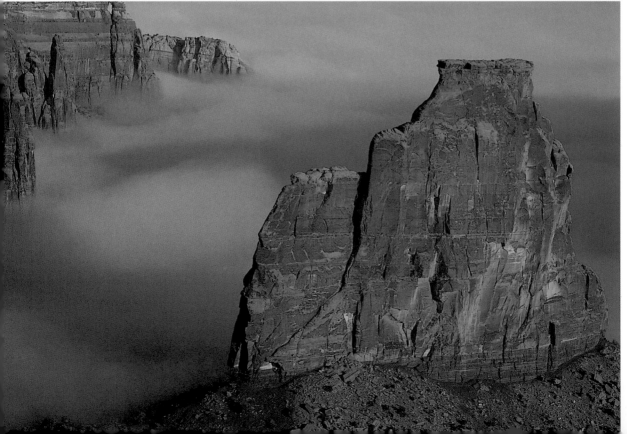

especially true along the seacoast, where the movement of the waves, during a several-second exposure, gives a soft, misty, ethereal effect.

Moody Lighting

Moody lighting is what all photographers hope to be able to experience and record. With often-photographed subjects, moody lighting assures that the image will be different from, and maybe more dramatic than, any other photographs taken at that location. But moody conditions are not easy to anticipate, do not happen frequently, and are usually of short duration. You have to be both lucky and good to record an image with outstanding mood. People often think that just capturing a rainbow or recording the color from a sunrise or sunset will produce a memorable photograph. That is not the case. Interest-

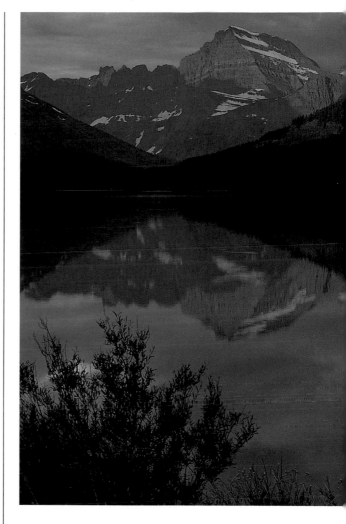

Twilight at Bandon Beach, Bandon State Park, Oregon. *Minolta 70–210mm lens, no filters, Kodachrome 200 film.*

This image was recorded about twenty minutes after the sun had gone below the horizon. The afterglow, which colored the sky pink, was reflected by the ocean and beach. The 2-second exposure softened the waves and made the water look soft and velvety.

Independence Monument in fog, Colorado National Monument, Colorado. *Minolta 70–210 mm lens, polarizing and enhancing filters, Fuji Velvia film.*

I own a home right at the base of the cliffs of Colorado National Monument. Looking out my window about sunrise one morning, I saw fog in the valley. I immediately grabbed my camera gear and drove up into the monument. From the rim of the canyon, I could look down at Independence Monument rising above the fog-filled valley. I quickly shot about two rolls of film before the fog dissipated.

Sunrise at Swiftcurrent Lake, Glacier National Park, Montana. *Minolta 35–70mm lens, polarizing, enhancing, and split neutral-density filters, Fuji Velvia film.*

The morning was heavily overcast, but we dutifully set up our cameras and put on our enhancers, polarizers, and split neutral-density filters. Suddenly the peak glowed red as a slit of clear sky opened up near the horizon. Within minutes, the opening closed and the light was gone. Without anticipation and preparation, recording this unique image would have been impossible.

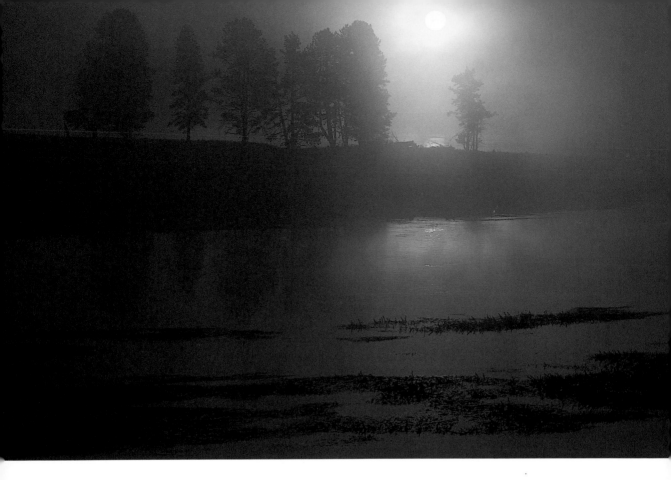

Above: Sunrise at Alum Creek, Yellowstone National Park, Wyoming. *Minolta 70–210mm lens, enhancing filter, Fuji Velvia film.*

 The river and trees provide good compositional elements. When the amount of fog is just right, the sun will impart an orange glow to the scene. When too much fog is present, the whole scene disappears. When too little fog is present, the sun causes lens flare. Many visits to this spot were required to obtain exactly the right conditions.

Opposite page: Sunrise at Mather Point, Grand Canyon National Park, Arizona. *Minolta 35–70mm lens, polarizing and enhancing filters, Fuji Velvia film.*

 The most effective photographs of the Grand Canyon are taken within an hour of sunrise or sunset. The colors are more intense, and the long shadows make buttes and cliffs stand out from the rest of the canyon.

ing subject material and good composition are also imperative.

 The most important element is anticipation. Taking advantage of special lighting conditions is difficult or impossible unless you are in the field, set up on an outstanding scene, and ready to photograph. I've spent countless hours waiting for sunrises or sunsets, or for the clouds to break, and frequently have come up empty-handed. But the outstanding images captured on those rare occasions when hoped-for conditions actually developed more than made up for all of the disappointing times.

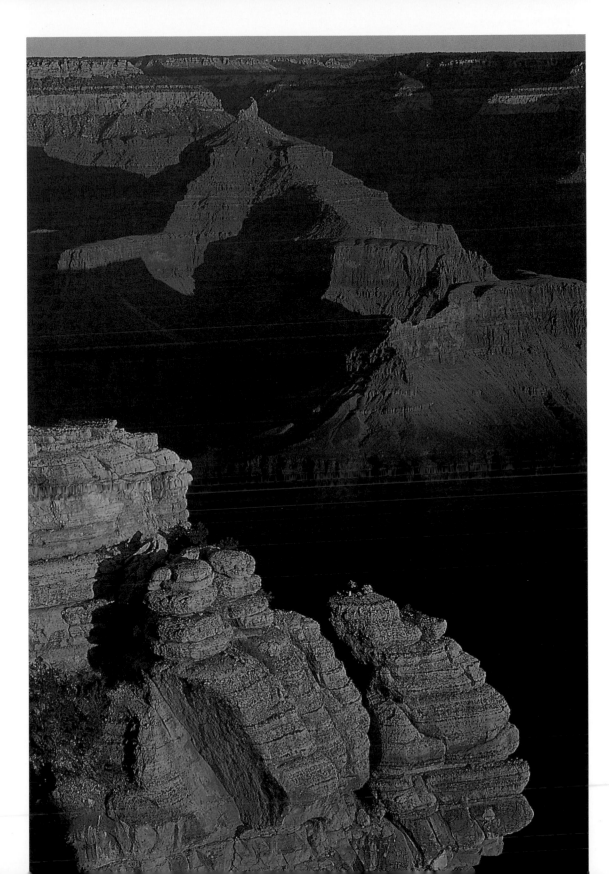

It's also necessary to quickly recognize the best composition and to have proficiency in using your equipment. These situations do not last very long. You don't usually have much time to deliberate about composition, filtration, or exposure. You must make decisions quickly and carry them out with precision and speed.

Fog is one of the moody conditions I most enjoy. If the fog is too heavy, photography is impossible. But usually, as the sun comes up and the morning progresses, the fog begins to dissipate. During the period of time when the fog is clearing, some stunning and artistic photographs can be recorded. In the fog, strong elements like trees or rocks become silhouettes and are very graphic. The fog also separates near elements from far elements, providing a wonderful feeling of depth. The ball of the sun shining through the fog is usually diffused enough that it won't cause lens flare, and it can be used as a powerful element in the composition.

Part of my affinity for Yellowstone National Park is the frequent occurrence of foggy conditions in the morning hours. Steam from the thermal areas, as well as steam rising from the park's many lakes and rivers after a cold night, provides photographic opportunities that change each day.

Early and Late Lighting

The quality of the light that falls on a subject during the half hour immediately after sunrise and the half hour immediately before sunset is outstanding. The light is warmer, softer, and more dramatic than at other times of the day and, because of the low sun angle, provides long shadows and rich texture. The exact times and direction of sunrise and sunset, presuming that clouds low on the horizon do not interfere, are predictable, and you can plan to take advantage of this rich light. A large percentage of my photographs, including many of the ones I enjoy the most, were taken close to sunrise or sunset.

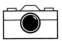
Understanding Exposure

What Is Correct Exposure?

Determination of precise exposure is a serious concern for amateur and professional photographers alike. The reason for this concern, in my opinion, is that no method is currently available that will guarantee perfect exposures. You can obtain readings from a number of very sophisticated electronic instruments, but in the end, you must make a subjective decision about what to do with this data. In this chapter, we will talk about the principles involved in the determination of exposure and how to build confidence in your ability to obtain perfect exposures.

In the discussions of composition and lighting, there was no need to differentiate between slides and negatives; the same principles apply to both. With exposure, however, slightly different philosophies apply. Slide makers must be very precise with their exposures. Negative shooters, because the prints can be made lighter or darker in the lab, do not need to be as exact. Negatives can be as much as one stop too dense or too thin and still yield prints that are almost indistinguishable from ones made from the perfect negative. Another difference is that slide makers are primarily concerned about preserving detail in highlight areas, whereas print makers are more interested in preserving detail in shadow areas.

For slides, the correct exposure is dependent on the individual photographer's tastes, the size of the projection screen, the surface composition of the screen, the aperture of the projection lens, and the power of the projector lamp used to show the slides. Some photographers prefer lighter exposures, and others like more color saturation. Given constant illumination, the larger the projection screen, the lighter the slide will need to be to provide proper exposure. Matte screens reflect at least a half stop, and possibly as much as one full stop, less light than either a glass-beaded or lenticular screen. Given constant illumination, proper exposure would be lighter for a matte screen than for a glass-beaded or lenticular screen of the same size. For those who aspire to present slide programs, it's also important to have consistency of exposure among all the slides in the program.

Calibrating Your Camera for Average Exposure

To obtain the correct exposure in every situation, you must calibrate each camera body for average exposure. Why calibrate for average exposure? If you don't know what the correct setting is for an average subject, you will have no basis to make the required corrections for a subject that is brighter or darker than average.

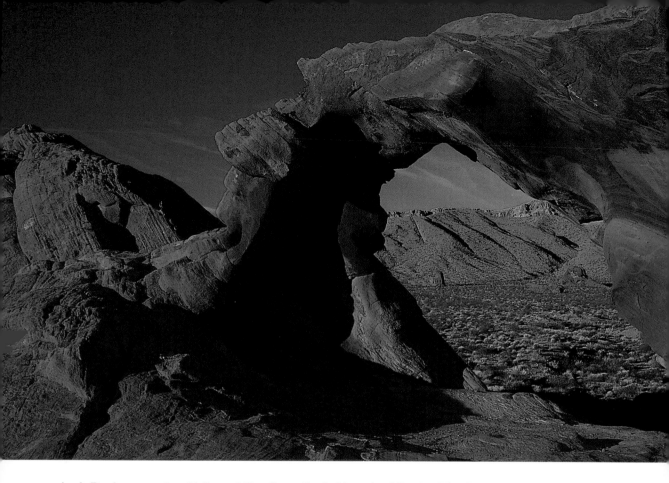

Arch Rock at sunrise, Valley of Fire State Park, Nevada. *Minolta 35–70mm lens, polarizing and enhancing filters, Fuji Velvia film.*

This photograph illustrates average exposure. Very little in this picture could fool the meter. This image could be exposed at what the meter reads whether using a full frame averaging meter, a matrix (evaluative) meter, or a spot meter reading on the rock.

Although your favorite film is assigned an ISO (formerly ASA) by the film manufacturer, your tastes may require some deviation from this value to obtain exposures that satisfy you. And each camera body may be different. Individual camera bodies, even ones of the same brand and the same model, may not be calibrated identically at the factory. With ISO 50 film, I have several bodies that I shoot "right on" and several others that I set at ISO 64 (-1/3 stop) to obtain the color saturation I require.

Here's how to evaluate average exposure on your camera body. Put your camera on a tripod and choose an average subject (one that doesn't have large areas of light or dark) for your test. Don't include much sky. If possible, shoot a number of sets of different average scenes to enlarge the statistical sample. Put your camera on automatic exposure; either automatic aperture preferred or automatic shutter speed preferred will work. Let's presume that you're using ISO 100 film. Shoot a set of pictures, on automatic, at ISO 64 (+2/3), ISO 80 (+1/3), ISO 100 (right on), ISO 125 (-1/3), and ISO 160 (-2/3). Keep good notes.

When you get the slides back, evaluate them with your projector and screen, or in

whatever manner you intend to use your slides. Pick the slide from the set that you believe is a perfect exposure, and note the ISO. With luck, this ISO value will be the same for all of your test sequences. The ISO value that you determine from these tests is what you should always use on that particular camera body for that film. If you use a different film, you can either assume that the amount of correction is the same and adjust by that amount, or conduct another test. My experience has been that most films are rated properly by the manufacturer and that variations from the advertised ISO are due to the individual camera bodies.

With DX coding of film on most of the newer camera bodies, the ISO is set automatically. If the value you determine for your body is different from the ISO coded on the cartridge, you will have to either change the ISO each time you put in a new roll or, if your camera body allows, set the ISO value so that it remains from roll to roll and ignores the DX coding. I do not recommend using the exposure compensation dial for changing the ISO; that should be used for a different purpose, which will be discussed later.

Grand Tetons in winter, Grand Teton National Park, Wyoming. *Minolta 35–70mm lens, polarizing and enhancing filters, Fuji Velvia film.*

This type of winter scene certainly should send up a warning flag from an exposure standpoint. If no compensation is made for the bright snow, the scene will be considerably underexposed. I took a raw meter reading on the snow, opened up a stop and a half, and bracketed around that value.

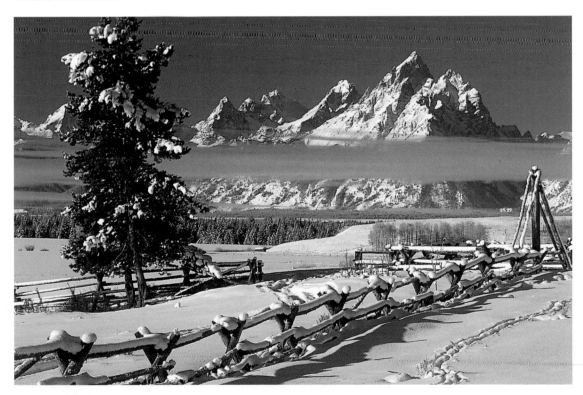

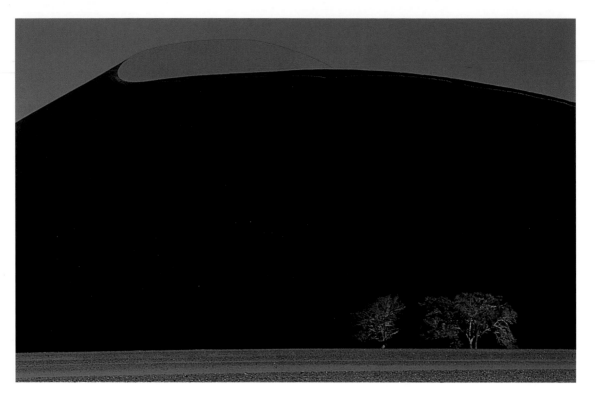

Namib dune at sunset, Namib Desert National Park, Namibia. *Minolta 70–210mm lens, polarizing and enhancing filters, Fuji Velvia film.*

The shadowed portion of the dune would certainly throw off any full frame averaging or matrix (evaluative) meter reading, and the photograph would be overexposed unless negative compensation is applied to the raw meter reading. I took a spot meter reading on the small portion of the dune that is sunlit and used that value as my median exposure.

Metering

In determining the correct exposure for a photograph, understanding some basic principles about light meters is important. All light meters are calibrated to 18 percent gray, or "average." What that means is that when using the meter reading for an average scene, the subject would be properly exposed. But for a winter scene, if the raw meter reading is used, the snow would also be rendered 18 percent gray, and the scene would be underexposed. Similarly, for a dark subject, using the raw meter reading would result in the photograph being overexposed.

Light meters fall into two basic groups: reflected light meters and incident light meters. Reflected light meters measure the amount of light reflected from the scene; incident light meters, which are pointed at the light source, measure the amount of light falling on the scene. Reflected light meters, which are built into most single-lens reflex cameras, are more useful in landscape photography. Incident light meters are much more suited to studio work.

Reflected light meters gather their information in many different ways. Knowledge of metering patterns is important, because

each has its strengths and weaknesses. Before choosing a new camera, you should determine which metering patterns are most suitable for your use. Many of the newer camera bodies incorporate several different metering patterns, which can be used for specific purposes. If you already have a camera body, you should know what the metering pattern is, what information it provides you, and how to use it to obtain the proper exposure.

Perhaps the simplest metering system is full frame average, which reads the light from all the objects in the frame and provides an average reading. Although full frame average metering is not very sophisticated, for scenes without a lot of bright or dark spots, this pattern works quite well.

Matrix, or evaluative, metering takes separate readings from many parts of the frame and puts them all together using a computer program that generates a final reading. Supposedly, experience gained in exposing thousands of actual photographs is employed in the logic of this metering system. I don't know exactly how it arrives at the final result, and I'm not sure many other people do, either. Most important, however, it appears to work quite well in a wide range of photographic situations.

Another common metering pattern is center-weighted average. This system takes information from all parts of the frame but gives most of the weight to objects near the center of the photograph. Center-weighted average metering is excellent for wildlife subjects because the animal or bird usually occupies the center of the frame. This system is less useful for landscape photography.

Spot meters take their readings from a very small area of the frame. They are very useful in reading exact light levels from a number of different locations in the frame. You can use these individual readings to determine an overall exposure for the entire scene. Raw spot meter readings should be used with caution, for if the spot is on the wrong subject at the time of exposure, the results could be erroneous.

Hand-held meters are also quite useful in the determination of correct exposure for landscapes. Hand-held meters that read the whole scene can be used either for reflected light readings or, with the addition of a small translucent cup, for incident light readings. Spot meters are also available in hand-held models. Since the metering system on my camera body is full frame average, I also carry a hand-held spot meter to check out specific areas of the frame when required.

How to Expose for Average and Problem Situations

Carefully study each scene and evaluate the light falling on it. Is the scene "average" with mostly middle tones, or are significant bright or dark areas present? If your analysis indicates mostly middle tones, expose the photograph at what the meter says. Since your meter was previously calibrated for an average scene, this should give good results.

If an analysis of the scene identifies significant bright or white areas, the picture should be given more exposure than the meter indicates. This extra exposure compensates for the higher meter reading caused by the bright areas in the frame. How much more exposure to allow is a subjective judgment based on the size and brightness of the light areas.

If the photograph contains bright rocks or a small amount of snow, I normally open up about a half stop from the raw meter reading. For example, if the meter reading is $1/60$ of a second at f/16, I would expose the picture at $1/60$ at f/13. An alternate method of obtaining the correct exposure for this type of scene is to take a spot meter reading on something with an average tone in the scene and use that exposure.

If the picture contains large areas of snow or white sand, such as at White Sands

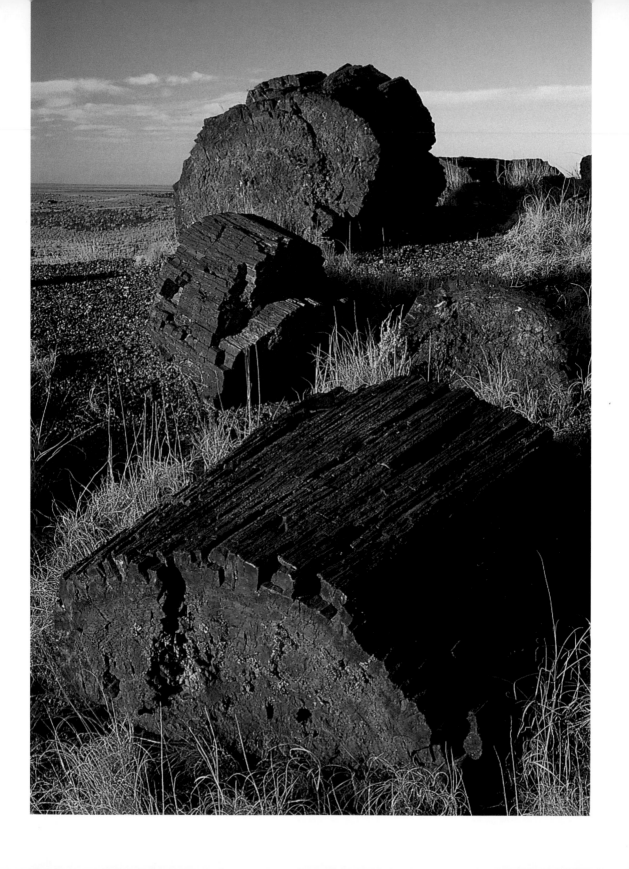

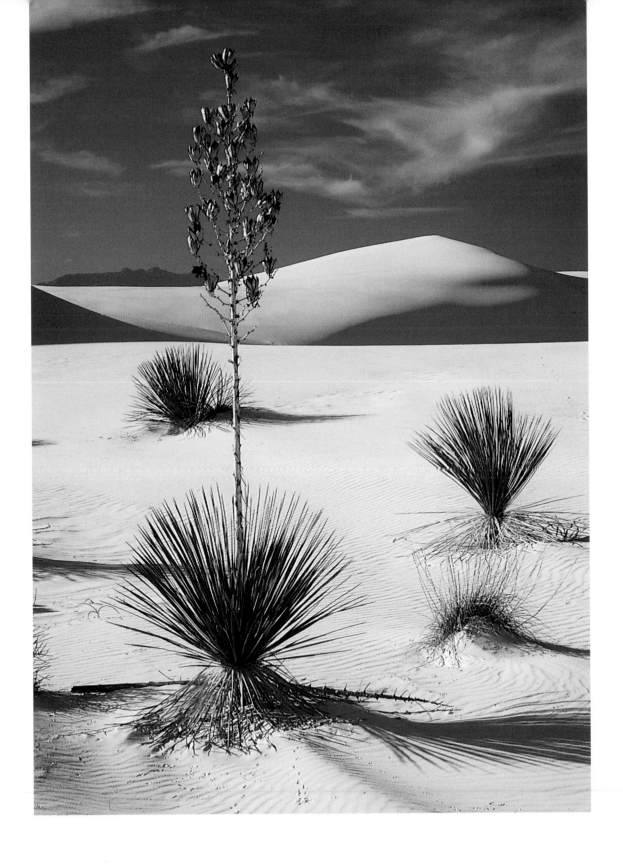

Page 52: Petrified logs pattern, Petrified Forest National Park, Arizona. *Minolta 35–70mm lens, polarizing and enhancing filters, Fuji Velvia film.*

This is another good example of a scene with mostly average light values. A light measurement taken with any of the metering systems we've discussed would yield a well-exposed image.

Page 53: White Sands dunes and yuccas, White Sands National Monument, New Mexico. *Minolta 35–70mm lens, polarizing filter, Kodachrome 64 film.*

The sand in this scene at White Sands National Monument is extremely bright. An overall reading would require at least one to one and a half stops of positive compensation for proper exposure. Bracketing of exposures is definitely needed in a high-contrast situation such as this.

National Monument, I would add one or one and a half stops to the exposure. For example, if the meter reading is $1/60$ of a second at f/22, I would expose the photograph at $1/60$ at f/16 or even f/13. Care must be taken when judging how much exposure to add to a bright scene near sunrise or sunset. Snow and sand are more shadowed at those times and are not white, so not as much compensation is needed. I would probably open up only a half stop on a snow scene near sunrise or sunset.

For scenes with significant dark or shadowed areas, you should give less exposure than the raw meter reading indicates. How much to stop down depends on how large and how dark the shadowed areas are. A scene taken near sunrise or sunset with an abundance of shadows should be intentionally underexposed by a half stop or a full stop. For example, if the raw meter reading is $1/30$ of a second at f/11, the photograph should be taken at $1/30$ at f/13 or f/16.

Another method of correctly exposing a partially shadowed scene is to take a spot meter reading on an unshadowed area and use that reading to expose the picture.

These corrections may be achieved either manually or by switching to automatic exposure and using the exposure compensation dial that appears on most single-lens reflex cameras. I prefer to do these adjustments manually. It is easy to use the compensation dial for one scene and then forget to take it off before photographing the next scene. If all the photographs for that day are to be taken under snowy conditions, however, dialing in a stop or a stop and a half positive compensation would be a reasonable thing to do.

Bracketing Exposures

At this point, the photographer must make a decision about how to expose the scene based on the raw light meter data and an analysis of the scene. But keep in mind that this decision is based on a number of subjective judgments about what the data means and what to do with it. How confident are you that the exact exposure you've decided on is the correct one? If you're a negative shooter, you don't need to worry, because the lab can bail you out if you're a half stop or even a full stop off. But if you're shooting slides, your exposure has to be perfect, and if you shoot just one exposure, you have a lot to worry about.

To ensure that you successfully photograph the image that you've worked so hard to compose, light, and frame, I strongly recommend bracketing your exposures when shooting slides. By bracketing, I mean intentionally shooting exposures on both sides of the median exposure you've decided on, based on information from your light meter and your judgment about how to use it. I recommend bracketing by half stops. Those with Nikons may want to bracket by one-third stops. I normally

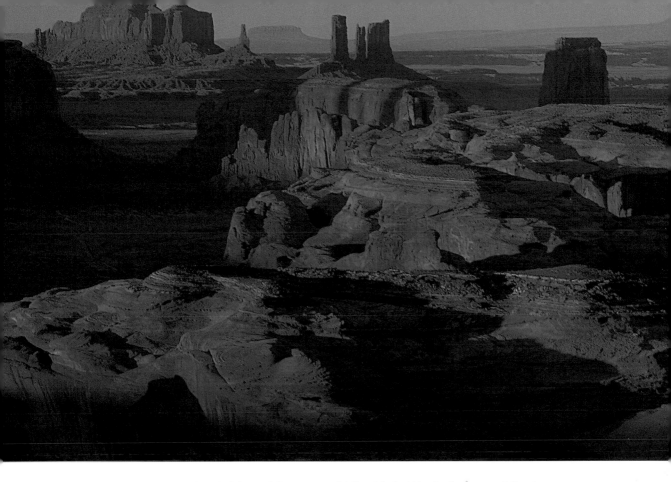

Monument Valley from Hunt's Mesa, Monument Valley Tribal Park, Arizona. *Minolta 70–210mm lens, polarizing and enhancing filters, Fuji Velvia film.*

In this image taken at sunset, a full frame averaging or matrix (evaluative) meter would certainly be influenced by the large shadowed areas. The exposure should be darkened half a stop from the raw reading. Alternatively, a spot meter reading could be taken directly off the sunlit rock and used as the median exposure.

expose one slide at the median value I've decided on, one at half a stop darker, and one at half a stop lighter. If conditions warrant, I may even expand the bracket to a full stop on one side or another, but always by half-stop intervals. Many of the newer single-lens reflex cameras have a feature called autobracketing that does all of this automatically.

Several well-known photographers have stated that bracketing is not necessary or desirable. They say that they can obtain perfect exposures every time without bracket-

ing and that bracketing exposures shows a lack of craftsmanship. I think that this attitude is based more upon ego than reality. Maybe there are a few photographers, somewhere, who are so precise and wise that they can hit the correct exposure perfectly every single time, but I've never met one.

My primary purpose is to obtain memorable images that are perfectly exposed. I do not regard bracketing exposures to achieve this goal a failing or a weakness. I don't consider myself to be so brilliant that I will make all the right decisions and get

perfect exposures every time. By bracketing, however, I can be almost positive that one of the exposures in the set will be perfect. I can sleep well at night knowing that I successfully recorded the images I worked so hard to create.

The obvious drawback to bracketing is wasting a lot of film and money on the exposures that are too dark or too light. However, the costs of reaching and photographing many localities are substantial. Moreover, many of the best photographic situations are unique and may be impossible to duplicate at a later date. Though film is no longer inexpensive, taking a few more exposures is cheap insurance, compared with all the other costs of a trip.

The Sunny f/16 Rule

No discussion of exposure would be complete without at least mentioning the "sunny 16" rule. This states that if the sun is shining, the correct exposure will be f/16 at the reciprocal of the ISO of the film. For exam-

The Silent City at sunrise, Bryce Canyon National Park, Utah. *Minolta 35–70mm lens, polarizing and enhancing filters, Fuji Velvia film.*

This photograph contains mostly rock of greater-than-average reflectance and some snow. With a full frame averaging meter or matrix (evaluative) meter, positive compensation of one stop would yield a well-exposed picture. With a spot meter reading off the bright rock, the lens should be opened up about half a stop for proper exposure.

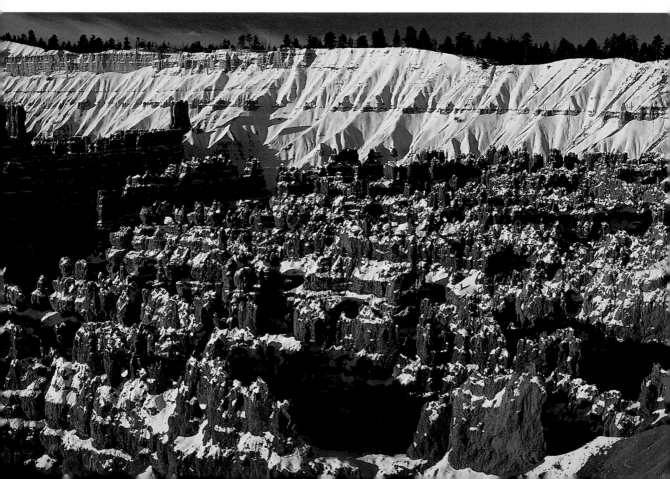

Pedestal Log—Blue Mesa, Petrified Forest
National Park, Arizona. *Minolta 35–70mm
lens, polarizing and enhancing filters, Fuji
Velvia film.*

*The "sunny 16" rule could have been used
to determine the exposure for this image. The
scene is somewhat frontlighted, contains pri-
marily objects with average reflectance, and
was taken about two hours after sunrise.*

ple, when using ISO 50 film, the exposure
would be $1/50$ of a second at f/16.

But a number of conditions must be met
for the sunny 16 rule to apply: The subject
must be frontlighted, of average reflectance,
and taken more than two hours after sun-
rise and two hours before sunset. Since I
rarely take frontlighted pictures and almost
always photograph within two hours of sun-
rise or sunset, I don't find the sunny 16 rule
very useful. I use the rule for two limited
purposes, however. The first is to ensure
that the exposure my light meter gives me
is in the ballpark. If it's not, several possibil-
ities exist. The meter may be malfunction-
ing. But usually I've failed either to change
the ISO after switching films or to return the
exposure compensation dial to zero.

The other situation in which I use the
sunny 16 rule is when photographing under
spotlighting conditions. Spotlighting occurs
when a scene is mostly dark, but shafts of
sunlight occasionally break through the
clouds and illuminate parts of the scene.
Most of the time, full sunlight is on the cen-
ter of interest for only a short time, and
waiting to take a spot meter reading during
that brief moment may cause me to miss
the picture completely. I assume that if and
when the sun does hit the intended center
of interest of the picture, the sunny 16 rule
will apply. I preset my exposure for those
conditions, plan to quickly bracket expo-
sures, and hope that the shafts of light
cooperate.

Equipment

Having the proper equipment is very important in obtaining good landscape photographs. Without the appropriate cameras, lenses, filters, tripods, film, and other miscellaneous items, recording the images that we envision would be difficult. It is important, however, to remember that all of these pieces of equipment are just tools, and that the real test of a photographer is the vision to create an exciting image.

For many individuals, the equipment used to record the image is far more important than the image itself. These folks are always talking about what equipment they have and what playthings they wish to purchase in the hope that they will become good photographers. Others purchase large-format cameras under the misconception that bigger and sharper is equivalent to better. These "equipment nuts" would be far better advised to improve their understanding of composition, lighting, and the other artistic aspects of photography.

Most photographers will obtain better results, especially in rapidly changing lighting conditions, if they really get to know their equipment and its capabilities. Those individuals who acquire a new camera body or lenses every year because of more gimmicks will never have this advantage.

Photography should be fun. Lugging around big cameras, numerous lenses, heavy tripods, and useless doodads will severely diminish the enjoyment of photography. Choose your equipment selectively, with special emphasis on versatility, portability, and affordability.

Cameras

After presenting one of the photographic programs that my wife, Bonnie, and I produce, I usually open up the floor to questions from the audience. Invariably, I am asked what brand of camera I use. The inference is that if only the questioner had the same camera, it would become simple to produce photographs like the ones he or she has just seen. My answer is always the same: "Any good single-lens reflex camera will do the same thing. The camera is just a fancy box with film in it. The eye of the photographer behind the camera makes the difference in the images that are created."

Any of the best-known manufacturers, such as (but not limited to) Canon, Nikon, Minolta, and Pentax, market high-quality cameras and lenses that will produce equally good results. There are five main considerations when deciding which make and model of single-lens reflex to purchase:

• Which camera has the features you really need?

• Which camera is the most convenient to operate?

• Does the manufacturer offer a complete line of lenses and accessories?

• What kind of batteries power the camera?

• Are you getting real value or just paying for a brand name?

Cameras used for landscape photography can be considerably simpler than those used for wildlife photography. Having only one camera system for all of your photographic interests is highly desirable from the standpoint of cost and portability. Let's look at some of the common features available on single-lens reflex cameras today, along with their importance to landscape photography.

Autofocus. Autofocus is not needed and is an annoyance for landscape work, but it's hard to avoid, as most cameras sold today have autofocus. Fortunately, the autofocus can be turned off on many cameras.

Automatic exposure. Although I normally shoot on manual exposure, the capability of having aperture priority automatic exposure is useful when trying to maintain a constant aperture while bracketing exposures.

Depth-of-field preview. This feature is desirable but not mandatory.

Autobracketing. This feature is useful under rapidly changing conditions, but it's available only on cameras with automatic exposure and motor drive.

Motor drive. A motor drive is seldom needed except for automatic bracketing. It adds to the weight of the camera and increases battery usage.

Metering. It is desirable to have both a full frame metering mode, such as matrix (evaluative) or full frame averaging, and also a spot-metering mode, which can be used for precise readings of small areas.

Exposure Compensation Dial. This feature is useful when bracketing exposures on automatic exposure. Almost all modern cameras have it.

Program modes. These are definitely not needed. I've never used a program mode for any purpose.

Batteries are a crucial part of any modern camera system. They are used to operate the exposure meters, release the shutters, focus the lenses, and advance the film on most camera bodies today. The type of batteries a camera uses should be a consideration in which camera brand and model you purchase.

The principal types of camera batteries are standard AA, rechargeable nicad AA, lithium, and silver. Standard AA and rechargeable nicad AA are usually interchangeable. Standard AA are relatively inexpensive, available throughout the world, and fairly reliable in cold temperatures. Nicad AA are initially expensive but can be recharged, so they are more economical in the long run. Under very cold conditions, nicads are the most reliable of all the types of batteries presently available. In foreign countries, the proper electric current may not always be available to recharge nicads. Lithium batteries have the advantage of long shelf life but are very expensive, lose a lot of their power in cold weather, and are not easy to find in out-of-the-way places. Silver batteries are used mostly in camera bodies that are not autofocus. They are relatively inexpensive and usually available but are prone to failure in cold conditions.

Lenses

The lenses that you will use for landscape photography should be chosen very carefully. The most important qualities are sharpness, color balance, and versatility. Purchase brand-name lenses whenever possible. If you own a Canon, buy Canon lenses. They were designed for your camera, exhibit consistent color balance within the system, and will, over the long run, provide better service.

If your favorite camera manufacturer doesn't make the particular lens you want, or if the comparable brand-name lens is just too expensive, an off-brand lens may be a

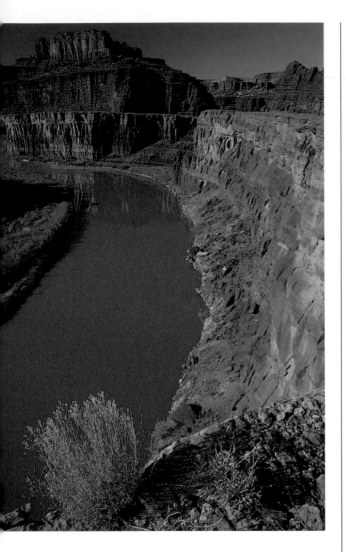

Colorado River from Shaffer Trail, Grand County, Utah. *Minolta 24–35mm lens, polarizing and enhancing filters, Fuji Velvia film.*

This photograph shows the great depth of field that can be attained with a 24mm lens at f/22 when focused at the hyperfocal distance. The shrub at the edge of the cliff was only 1½ feet from the lens, and the river and canyon were at infinity. Oversize polarizing and enhancing filters were used to prevent vignetting in the corners.

good purchase. My favorite off-brand manufacturer is Tokina. I've found, from experience, that variability in color balance is the principal drawback of off-brand lenses. The best way to check for color shifts is to photograph a scene with both the new lens and a lens you believe has good color rendition. If the new lens flunks this test, return it to your dealer.

The photographs that I've chosen to illustrate this book span a wide range of focal lengths all the way from 17 to 600mm. I cover this range completely with a number

of zoom lenses. As discussed in the chapter on composition, zoom lenses allow for exact cropping and are, for all practical purposes, just as sharp, contrasty, and properly color corrected as fixed focal-length lenses. As a general rule, the smaller the zoom ratio (a 35–70mm lens has a zoom ratio of 2, and a 35–105mm lens has a zoom ratio of 3), the sharper and less expensive the lens will be.

There are a number of other features that you should investigate before purchasing any new lens:

• What is the filter size? Will the new lens require a new and larger set of expensive filters?

• Does the lens have a depth-of-field scale on the barrel? Most new autofocus lenses don't. At a minimum, you need a depth scale to be able to set the hyperfocal distance you obtain from a hyperfocal distance chart (see part 2).

• What is the weight of the lens? For landscape photography, extremely fast (f/1.4 or f/2.0) lenses are not necessary. The large amount of glass in these fast lenses makes them comparatively heavy.

• What is the minimum aperture of the lens? Since a large amount of depth of field is sometimes required for landscape photography, the smallest aperture should be at least f/22. For telephoto lenses, f/32 is required.

Filters

The proper use of filters can add to the beauty, impact, and mood of most landscapes. Some nature photographers are purists and choose not to use filters to alter the true colors and emphasis of the scene. This a personal choice that each photographer must make. When photographing landscapes, I use certain filters for specific purposes. Many of the more exotic filters on the market certainly have a place in contemporary photography but, in my opinion, not in landscape photography.

Several common filters that I don't own or recommend are the UV, skylight, and haze filters, which supposedly reduce the effects of haze or excessive blueness at high altitude. Their contribution is negligible, and a polarizing filter is a far more effective remedy for either of those problems. Another stated use for the UV, haze, or skylight filters is to protect the lens from scratches. A polarizer will protect just as well and, at the same time, provide other significant benefits.

A question that I'm often asked is whether sharpness will suffer if the photographer uses two filters simultaneously. Theoretically, anytime a piece of glass is put over the lens, a decrease in sharpness will result. If clean, good-quality filters are used, however, any loss of sharpness will be insignificant. For landscapes, I keep two filters—an enhancing filter and a polarizer—on my lenses most of the time. I may remove one or the other for specific images, but most of the time I use them together, with negligible loss of sharpness.

With wide-angle lenses, using one or more filters of the recommended filter size may cause vignetting in the corners of the image. This problem can be prevented by using a step-up ring at the lens along with oversize filters. For example, my Minolta lenses all take 55mm filters, but I step up to 72mm filters and never have any vignetting

problems, even at 24mm. Each lens varies, so check your own lenses and images carefully for evidence of this problem. When using ultra-wide-angle lenses, even this remedy may not always be successful.

Polarizing Filter

The polarizing filter is the most essential filter available for landscape photography. It can be used effectively with either color or black and white film. The best known effect of a polarizing filter is darkening the sky, which puts more emphasis on the important elements in the photograph below the horizon. By darkening the sky, the polarizer also brings out any attractive clouds that may be an asset to the image. A polarizing filter also reduces atmospheric haze and removes reflections from the surfaces of nonmetallic objects. Colors become more saturated, and the partial elimination of reflections on water surfaces allows rocks and other objects below the surface to be seen. The polarizing filter even has beneficial effects when the sun is not out. Reflections of an overcast sky on leaves and rocks are easily removed through polarization, making colors more saturated.

The maximum effect when using a polarizing filter occurs when the sun is at right angles to the camera. The sun may be on either side of the camera or even directly above the camera. When the sun is directly overhead, however, the quality and direction of light are not appropriate for landscape photography. If the sun is at an angle less than 90 degrees from the direction in which the camera is pointed, polarization will be less than maximum. Care must be taken, especially with wide-angle lenses, to ensure that the sun angle is as close to 90 degrees as possible. Otherwise, the sky on one side of the image will be noticeably lighter than the sky on the other side of the image.

Many people, while appreciating the other benefits of the polarizing filter, don't

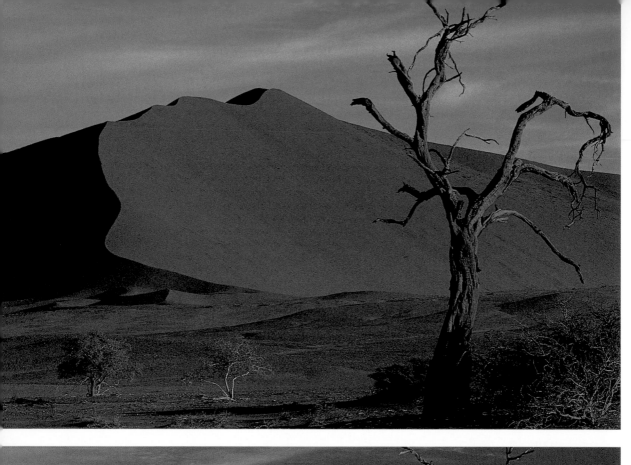

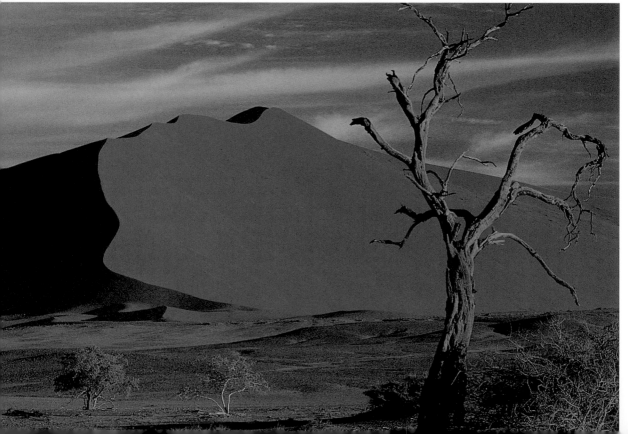

Namib dunes—Tsauchab River, Namib Desert National Park, Namibia. *Minolta 70–210mm lens, without (above) and with polarizing filter, enhancing filter, Fuji Velvia film.*

This pair of pictures illustrates the tremendous difference a polarizing filter can make. The polarizer darkens the sky, bringing out the wispy clouds. In addition, all the colors are warmer and more saturated. An enhancing filter was used for both photographs.

like the dark sky it may create, especially when pointing up at a very steep angle to photograph a spire or mountain. Fortunately, with a single-lens reflex camera, you can see exactly what effect the polarizer has on the scene. You can choose to only partially polarize so that the sky is not so dark as it would be if fully polarized. But with partial polarization, the other effects are reduced as well.

Polarizing filters are available in two types: linear and circular. Linear polarizers are used with most non-autofocus cameras. Circular polarizers are required when using autofocus. Knowing the theory about how each of these polarizing filters works is unnecessary. If in doubt about which is applicable to your camera, consult your instruction manual. Either type of polarizing filter has a filter factor of 3 to 4. This means that the light reaching the lens, when using a polarizing filter, is reduced by one and a half to two full stops. Fortunately, a through-the-lens meter automatically takes this light reduction into account. Circular polarizing filters are more expensive than linear ones, but both are comparatively modest in price and should be purchased and used by any serious landscape photographer.

Color Correction Filters

Color correction filters can be used to either warm up or cool down the colors recorded on film. The 81 series filters, which are amber in color, warm up the image; the 82 series filters, which are bluish in color, cool it down. Both series come in grades A, B, and C. The A filter produces a small effect, and the B and C filters produce successively larger effects. For example, the 81A filter is a light amber filter that warms the image slightly, and the 82C filter is a bluish filter that cools the image considerably. Of these color correction filters, the only one I use is the 81A filter. It is useful for the following reasons:

• When photographing with films that have a bluish cast, such as Fuji Sensia or Provia, the 81A filter returns the rendition to neutral.

• When photographing snow scenes, many films exhibit a slight bluish cast, especially in shadow areas. This effect is most noticeable at high altitudes. The 81A helps eliminate this bluishness.

• My Canon lenses produce slightly cooler colors than my Minolta lenses, so I usually use an 81A with the Canon lenses to make the color balance slightly warmer.

• When photographing autumn colors, the 81A filter adds even more warmth to the foliage.

The 81B or 81C filter could be used for the same purposes if the 81A does not warm up the scene as much as desired. The 82A, 82B, or 82C filter could potentially be used at sunrise or sunset if you feel that the light is too warm. I love warm light and have never used an 82 series filter.

Enhancing Filter

The enhancing filter has a special formulation incorporating rare earth elements and operates primarily on the warm portion of the visible light spectrum. It enhances reds, oranges, rusts, and maroons but has little effect on blues, greens, and yellows. Its primary applications are in enhancing the warm colors in autumn foliage, sunrises and sunsets, red rock, and other miscellaneous

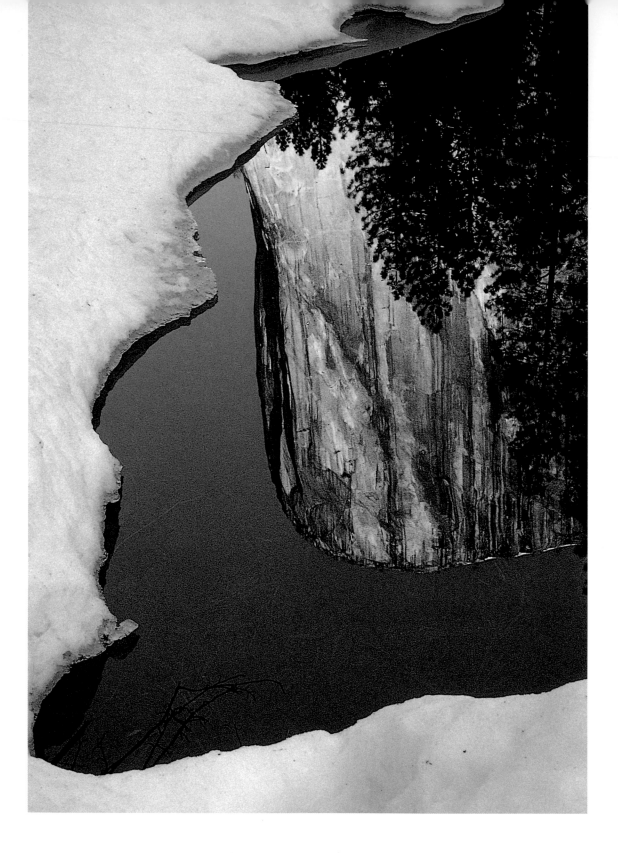

subjects such as barns, flowers, and sand dunes. In images containing large areas of white or off-white colors such as winter scenes, white sand, spray from waterfalls, or steam from geysers, the enhancing filter may introduce a slight pinkish tinge.

I use the enhancing filter for another specialized purpose: to correct the slight greenish bias of Fuji Velvia film. The color saturation and sharpness of Velvia are superb, but the slightly cyan cast, especially in the sky, always bothered me. A few years ago, I became disenchanted with the film I'd been using and decided to try Velvia. The day was hazy, and the scene at Red Rock Crossing near Sedona, Arizona, was certainly not memorable. In an act of desperation, I added an enhancing filter to try to give the image some punch. When I got back my slides, I couldn't believe the results. The uninspiring reds were improved tremendously, and the sky, instead of having that objectionable cyan cast, was pure blue. I've used Fuji Velvia film with the enhancing filter ever since, and I never cease to be amazed at the results.

Split and Graduated Neutral-Density Filters

The split neutral-density filter and graduated neutral-density filter are useful for several specific purposes. The principal use is to even out the exposure when part of the image is in bright sun and part is in shadow. Without this filter, the contrast between sunlit and shadowed areas is too great to allow both to be properly exposed at the same time. Another use is when photographing reflections on lakes and streams. Even when the scene and its reflection are both in the sun, the difference in exposure between the two areas is approximately one stop. You orient these filters so that the dark part is over the bright part of the scene and the clear part is over the darker part of the scene.

I use the split neutral-density filters at the same time as polarizing and enhancing filters without apparent loss of sharpness. When photographing with negative film, split neutral-density filters are not necessary, because bright and dark areas can be balanced later in the darkroom.

The split neutral-density filter is half clear and half neutral gray, with a relatively thin transition zone in between. The graduated neutral-density filter has a little wider transition zone. You can purchase either screw-on filters or small, square sheets of glass or plastic for use in Cokin holders. I strongly recommend the Cokin-compatible system. The square filter can be positioned in the Cokin holder so that the split coincides precisely with the position of the shadowed area, whether the dividing line is in the center or near the top or bottom of the image. Screw-on filters have the dividing line in the center of the filter, and you're stuck with that configuration whether the scene calls for it or not.

The Cokin system features two sizes of holders and filters: the 4-inch P (professional) size and the 3-inch A (amateur) size. I recommend the larger P filters and holder, especially for use with wide-angle lenses. The smaller A filters, when used with wide-angle lenses, may not cover the entire field of view. Cokin makes two plastic split neutral-density filters, which are reasonable in price (about $25). The #120 has one and a half stops difference in density between the

El Capitan winter reflection, Yosemite National Park, California. *Minolta 35–70mm lens, 81A filter, Kodachrome 200 film.*

Without a warming filter, this shadowed, snowy image would certainly have taken on a bluish cast. I used an 81A filter to ensure a neutral rendition of the snow. Though the water is quite close to the camera, the reflection of El Capitan is at infinity. A small aperture was needed to obtain the depth of field required.

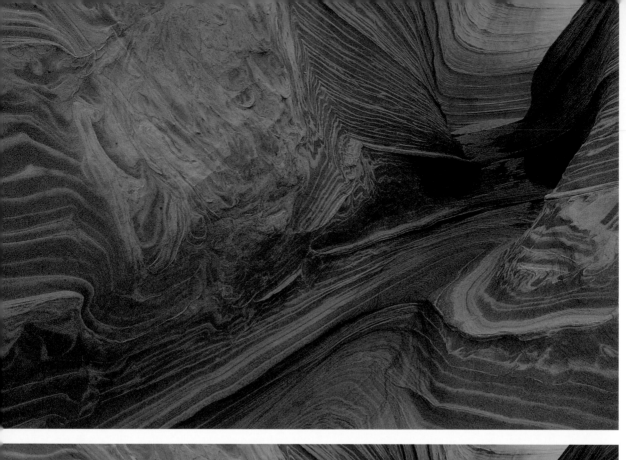

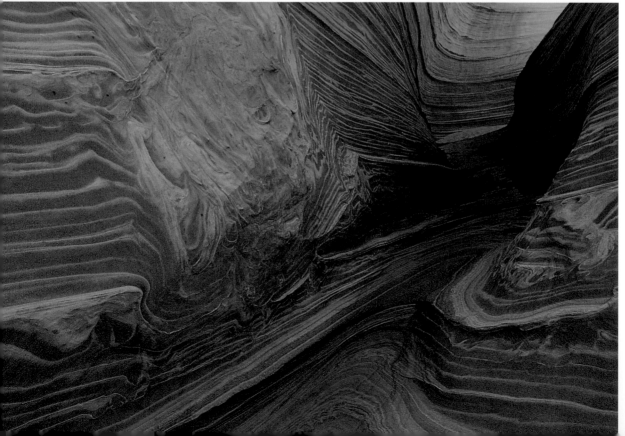

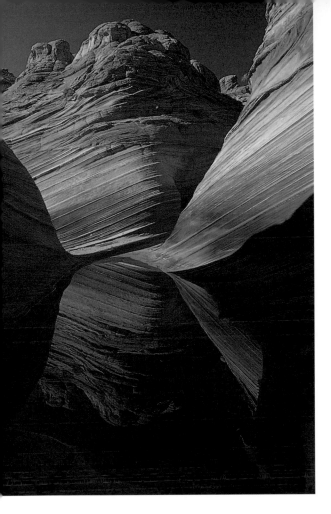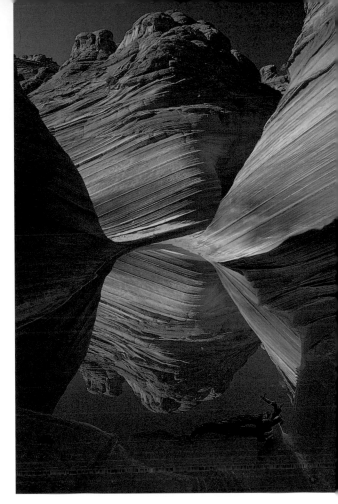

Above: Coyote Buttes reflection, Paria River–Vermilion Cliffs Wilderness. *Minolta 24–35mm lens, polarizing and enhancing filters, without and with Cokin #121 split neutral-density filter, Fuji Velvia film.*

The cliff and its reflection would have been impossible to photograph successfully without a split neutral-density filter. I measured the light falling on the cliff and the reflection of the cliff, and found that these two values were about two and a half stops apart. The left image, exposed without a split neutral-density filter, has no detail in the foreground. The right image, using the #121 Cokin filter, which has about two and a half stops of split neutral density, captures the beauty of the pool.

Opposite page: Sandstone patterns, Coyote Buttes, Paria River–Vermilion Cliffs Wilderness. *Minolta 24–35mm lens, without and with enhancing filter, Fuji Velvia film.*

These two photographs are identical except that an enhancing filter was used on the upper image and not on the lower. The enhancer certainly adds color and drama to the scene. While the effect of the enhancer on Fuji Velvia is very pronounced, the enhancing filter accentuates warm colors with other films as well.

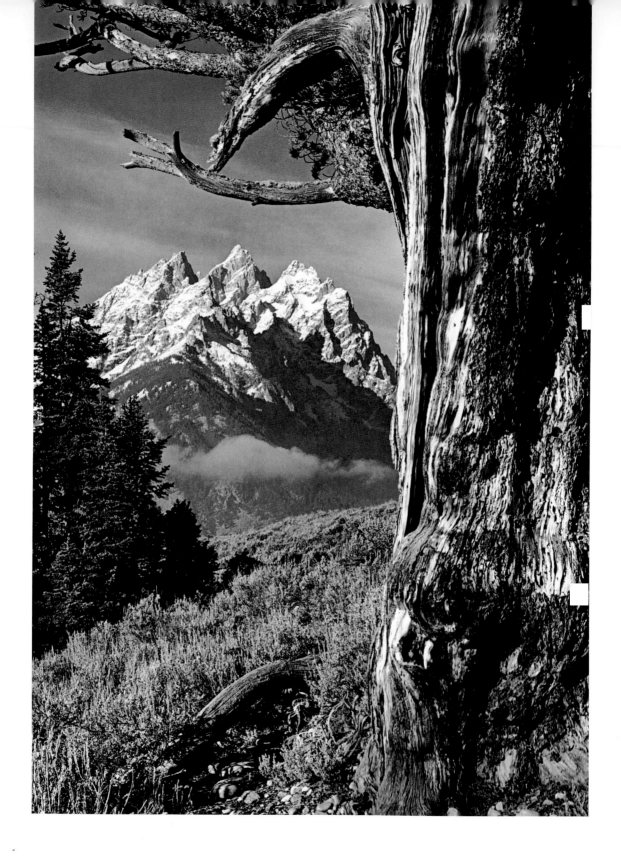

dark and clear areas, and the #121 two and a half stops. Tiffen makes a series of graduated neutral-density filters labeled the .3, .6, and .9. These glass filters may be slightly better optically but are more expensive (about $75). The .3 has about .7 stop difference in density between the clear and dark areas, and the .6 about 1.4 stops. I do not own a .9 Tiffen graduated neutral-density filter. Other, much more expensive brands of split neutral-density filters are available, but I don't think they're worth the difference in price.

My threshold for using these filters is when there is one full stop difference in exposure between important light and dark areas. Which filter to employ depends on the difference in exposure between the dark and light areas. Simply take a light meter reading on both areas separately and note the difference in values. Then choose the split filter that comes closest to this difference without exceeding it. Once the split neutral-density filter has been positioned, exposure for the whole scene may be metered through the lens. Bracketing of exposures is certainly called for under these conditions.

When photographing reflections, make sure that the reflection is not rendered lighter than the actual scene. This never happens in nature. As a rule of thumb, when the scene is in sun and the reflection is still in shadow, the readings on scene and reflection are usually about two stops apart. I would choose the Tiffen .6, with 1.4 stops

difference between light and dark, or the #120 Cokin with 1.5 stops difference. After installing this filter, the reflection would still be .5 stop darker than the scene. If both the scene and the reflection are in the sun, the readings will usually be only about one stop apart. Here I would choose the Tiffen .3, which has .7 stop difference between light and dark. This would render the reflection .3 stop darker than the scene.

The greatest difference between light and dark areas that I've ever encountered when photographing was at sunrise at the Grand Canyon. The sun was still below the horizon, but the sky and clouds were bright and colorful, while the canyon below was in deep shadow. The difference in light readings between these two areas was in excess of five stops. I used both the #120 and #121 Cokin filters simultaneously, for a total difference of four stops, and obtained a beautiful image.

Filters for Black and White Photography

The main focus of the book to this point has been on color photography. But certain landscapes, especially where strong lines and contrast are present, can yield stunning images when photographed in black and white. I printed black and white photos in my own darkroom for many years before concentrating on color printing. Most of the preceding discussions on composition, lighting, exposure, and equipment apply equally to black and white photography.

Many colors in black and white photographs would be recorded in similar shades of gray without filtration. Filters help to differentiate these shades of gray by darkening some and lightening others, providing contrast. They can be used effectively to direct attention to the center of interest in the frame.

The most often used filters for black and white film are red, orange, yellow, and green. Many shades of each of these basic

The Old Patriarch, Grand Teton National Park, Wyoming. *Mamiya C-220 (2¹/₄ square), 80mm lens, orange filter, Kodak Plus X film.*

This ancient limber pine in Jackson Hole makes a wonderful frame for the Cathedral Group. The spectacular shapes of the peaks and the strong lines of the old tree make this a good black and white image. An orange filter, chosen to lighten the trunk of the tree and darken the sky, provided added contrast.

colors are available. A polarizer can also be very effective with black and white film. To lighten a color, use a filter of the same color. To darken a color, use a filter of the opposite color. The opposite of red is green, the opposite of yellow is purple, and the opposite of blue is orange.

Let's take, for example, a scene with a red rock arch, a blue sky, and some green vegetation. We would like to lighten the rock, so that the eye would be drawn there, and at the same time darken the sky and the vegetation. To accomplish this, we could choose a red or orange filter. From my experience, the red filter sometimes renders the sky a little too dark, so an orange filter might be more appropriate. For a photograph of some giant saguaro cacti against the sky, we might choose a green filter to lighten the cactus.

Tripods

Tripods are a necessary evil. They are heavy and awkward, take time to set up, and are hard to adjust, but they are mandatory for two very good reasons: to establish a rock-solid base of support so that the camera does not move during the exposure, and to force you to work harder on your composition. Having your camera on a tripod enables you to make a lot of small adjustments, including camera position, exact cropping, and identification and removal of distracting elements within the frame.

Tripods come in various sizes, shapes, and prices. The tripod you choose should be solid enough to adequately support the largest camera system and lens you plan to use for landscapes. Obviously, the photographer who uses view cameras will need a much larger and heavier tripod than one who uses only 35mm equipment. If you buy a tripod that is larger and heavier than you need, you'll have to lug that extra weight everywhere you go, and you may be tempted to leave it in the car when the going gets tough. On the other hand, a tri-pod that is too light will not properly support the camera. The tripod you choose should extend to at least eye level and be capable of going to low camera positions as well. I also recommend clamping leg locks rather than twist locks, which occasionally will not unlock properly, causing undue frustration and delay.

The best tripods combine true quality with reasonable price. Some brands are of excellent quality but are very expensive. The Bogen tripods are of moderate cost, however, and their quality construction will last for years. Other tripods may be initially lower priced than the Bogen, but in my experience, they don't hold up as long.

The tripod head is another very personal decision. I don't like the heads with three handles that control the three separate movements of the camera. In pressure situations when light is changing rapidly, you can lose a lot of time looking for the correct knob. And if the vertical adjustment handle is too long, it keeps poking you in the chest while you're trying to compose the picture.

I recommend tripod heads with a quick-release feature, which saves a lot of time in mounting the camera on the tripod. Quick-release mechanisms should incorporate a safety lock, so that the camera cannot be accidentally dislodged when mounted.

My favorite tripod head is the Bogen 3265, known as the "Joy Stick." It features a hand grip that, when squeezed, allows the head to be rotated in any direction. When the grip is released, the head is locked firmly in position. With this head, the camera can be positioned rapidly and positively under quickly changing light conditions. The Bogen 3265 has a quick-release mechanism with a safety lock and is reasonably priced. It will firmly support landscape lenses up to about 300mm focal length.

Every photographer has different needs and preferences. The only way to successfully pick out a tripod or tripod head is to

visit your local camera dealer, compare the different brands and models, and choose the one that has the features you need.

Camera Bags, Packs, and Vests

When going into the field to photograph landscapes, you'll have a certain minimum amount of necessary equipment and accessories, including extra cameras, lenses, filters, batteries, cable releases, and film, that must be transported in some way. Three basic means of carrying equipment are popular: bags, packs, and vests.

Camera bags with straps, carried in the hand or over the shoulder, hold a lot of equipment in separate compartments and pockets. When used close to the car, camera bags are satisfactory, but they are extremely tiring when carried any substantial distance. Camera packs, which also feature convenient compartments and pockets, are a far better choice when hiking. However, I prefer a photo vest over either a camera bag or pack to carry my extra gear. My vest has separate padded pockets and compartments for all my lenses, film, and accessories. The pockets on my vest provide rapid and convenient access when I need a certain piece of equipment.

A number of manufacturers market quality camera bags, packs, and vests. I have used Tamrac packs and found them to be of high quality and reasonably priced. Some of the other brands are much more expensive. I unexpectedly found my present photo vest, which was made in England, in a tourist shop at Maligne Lake in the Canadian Rockies. Again, a visit to your local camera dealer will allow you to compare features and find a camera bag, pack, or vest that meets your specific needs and fits your budget.

Film

A great many different films are currently available, and by this time next year, some new ones probably will have been intro-

duced. The choice of which kind of film to use for a particular image is a personal one. Everyone sees color differently, and a color rendition that is satisfactory to one photographer may not be to another. Therefore, this discussion will concentrate not on specific brands or types of film, but on general characteristics.

For color slide film, generally speaking, the lower the ISO, the sharper the film, the better the color rendition, and the finer the grain. Since landscape subjects don't move around much (with the exception of ocean waves), high film speed is not normally needed. This allows the landscape photographer to choose a film with an ISO in the 50 to 100 range and be assured of high quality.

The two principal characteristics that must be evaluated before choosing a color slide film are color saturation and color rendition. Prior to the introduction of Fuji Velvia, most films produced color saturation that was close to natural. Their color biases may have differed, but saturation was normal or muted. Velvia changed all that forever. Its higher saturation produced colors that were more vivid than those found in nature. At first I found this added saturation objectionable, but as I saw more and more images with this brilliant color, I began to accept Velvia's characteristics as dramatic and desirable. To compete with Velvia, Kodak and other manufacturers have introduced films with enhanced color saturation. If you believe in reproducing nature exactly the way you see it, don't use these enhanced films. But if your objective is to achieve maximum impact and color, then an enhanced film should be your choice.

No one perfect color slide film exists. You need to try a number of different films to determine which one or ones suit your taste and subject material. Once a choice has been made, I heartily recommend staying with those films long enough to learn

Camera close-up.

This picture shows some of the equipment I use when photographing landscapes. An L-shaped bracket, attached to my Minolta X-700 camera, allows me to position the camera and lens directly above the axis of the tripod for either horizontal or vertical images. A quick-release plate attaches the L-bracket to my Bogen 3265 "Joy Stick" head. I attach a double-bubble level to the hot shoe to make sure the image is level in either horizontal or vertical format.

"happy snappies." I like a lot of contrast and color saturation in my landscape prints. I currently use Agfa HDC 100, but my preference may change as new films continue to be introduced.

Since the advent of T-grain technology, most black and white films, even the higher-speed films, have very good sharpness and fine grain characteristics. Any film in the ISO 100 to 200 range will probably do a superb job. Contrast and tone can be personalized by the choices of developers and papers.

Miscellaneous

I don't use or recommend many gadgets for landscape photography. Most serve no useful purpose and only mean more weight to carry. Among those that I consider essential are a cable release and a leveling device. Using a cable release minimizes the potential for any camera movement that may result from pushing the shutter release button manually. This problem is most prevalent at slow shutter speeds. Look for a model with a locking mechanism, which will enable you to keep the shutter open for time exposures of several hours' duration without remaining near the camera.

I recommend using a double-bubble level, inserted into the hot shoe, to ensure that the image is not tilted. A single-bubble level, available at many photo stores, will work

how to exploit their strengths and compensate for their weaknesses.

When shooting color or black and white negative films, the choices are much simpler. There are a number of excellent quality ISO 100 to 200 color negative films. The selection of a color negative film will probably be based on the degree of color saturation and contrast desired, since any color biases can be eliminated in the darkroom. Some color negative films exhibit more pastel colors and lower contrast; these are more appropriate for portrait work and

only for horizontal pictures. Two separate bubbles are needed to level both horizontal and vertical formats. This double-bubble level may be obtained from many of the big New York photo stores.

I also carry a few select tools for minor camera repairs, such as jeweler's screwdrivers in both flat-head and Phillips-head configuration and a small needlenose pliers. Also useful is a film retriever for those rare occasions when film is inadvertently wound back into the cartridge. I also carry a soft cloth to dry off my camera, lenses, and filters in case of light precipitation, mist from waterfalls, or ocean spray.

I attach a homemade L-shaped bracket to my camera body to allow the camera and lens to be positioned directly over the axis of the tripod when using a vertical format. It was designed for use with lenses that have no tripod collar and is especially effective with moderate telephoto lenses. It is simple in design and easy and inexpensive to build. To obtain one, contact Bill Baker, Feather and Fur Wildlife Photos, 1764 Lansing St., Aurora, CO 80010, telephone (303) 343-3607. Other devices that accomplish this purpose are available commercially, but most are awkward, heavy, complicated, and expensive.

Specific Techniques for Different Landscapes

For many types of landscapes, specific techniques play a relatively minor role in achieving memorable images. In the majority of cases, the most important ingredients are the ability to find interesting subject material, to compose the subject material artistically, and to recognize dramatic lighting, and the imagination to try different approaches. However, some landscape subjects require the knowledge of specific techniques to achieve outstanding results. This chapter looks at a variety of useful techniques for creating successful images.

Mountains

Mountains have long been a source of inspiration to artists and poets. As John Muir, famed naturalist and conservationist, noted more than a century ago: "Thousands of tired, over-civilized people are beginning to realize that going to the wilderness is going home. That mountain parks and reservations are useful not only as fountains of timber and irrigating rivers, but as fountains of life." Ansel Adams, the great pioneer photographer, will always be remembered for his stunning black and white images of Yosemite and the Sierras. The jagged peaks, rushing streams, sparkling lakes, luxuriant forests, and thundering waterfalls in the mountains continue to provide inspiration for the present generation of photographers.

Every season provides a different mood and unique photographic opportunities in the mountains. Spring brings awakening and rebirth. Streams, frozen or hushed during the long winter months, become rushing torrents as the warming sun begins to melt the snowpack. Deciduous trees leaf out. Wildflowers add color to the mountain meadows. Snow-covered peaks offer spectacular vistas.

In summer, nature's pace slows. As the snowpack diminishes, streams return to their banks, and the higher alpine lakes, meadows, and glaciers become accessible. Wildflower displays spread up the mountainsides as the season progresses.

Autumn brings crisp, clear days and cold nights. The gold and red of the aspens, cottonwoods, and other trees and shrubs add dramatic colors to the landscape. The first dusting of snow covers the peaks. Frost and fog cover the meadows in the early morning hours.

Winter brings quiet and tranquillity. As temperatures plummet and the snow deepens, the mountains are locked in winter's icy grip. Most streams and lakes are frozen solid. The pristine whiteness, strong shadows, and stark beauty of the mountains present stunning images.

A successful mountain landscape must, first and foremost, have outstanding subject material as its center of interest. This means

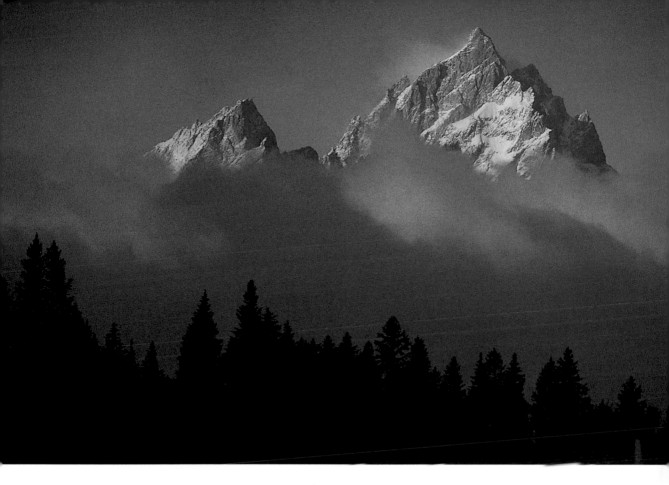

Storm breaking, Grand Tetons, Grand Teton National Park, Wyoming. *Minolta 70–210mm lens, polarizing filter, Kodachrome 200 film.*

My favorite time to photograph mountain scenery is when a storm is breaking or fog is lifting. To take advantage of such opportunities, you must anticipate that the clearing will occur and wait at a spot that has good compositional possibilities for the right combination of light and clouds.

choosing a peak that has an exciting shape, is rugged, is snow or glacier covered, or for some other reason commands attention.

Equally important is the choice of supporting material and the artistic arrangement of these elements in the photograph. Trees make outstanding framing material. Fields of flowers, rushing streams, jagged rocks, rustic buildings, fences, or winding roads can also be used successfully to help tell a story and enhance the interest and composition of photographs in which a peak is the dominant element. Moderate telephoto lenses are useful in isolating dis-

tant peaks or glaciers. Normal to wide-angle lenses can be employed to include or emphasize interesting foreground.

Early or late lighting is extremely important in photographing mountain scenery. At sunrise or sunset, the peaks, especially those that are snow covered, will take on exciting pink or even red hues that can be accentuated by the use of an enhancing filter. The soft, warm light of early morning or late afternoon adds color and shadow detail to the image. Different weather conditions, such as thunderstorms, rainbows, clouds, or fog, may add drama to mountain landscapes.

Photographing mountains in the middle of the day is a waste of time, energy, and film. The light will invariably be harsh, and the images overly contrasty and uninteresting.

Obtaining proper exposure in photographs featuring snow-covered mountains is more difficult than for some other landscape subjects. The snow should not be rendered without detail if it occupies a significant portion of the frame. Taking spot meter readings on the snow and then opening up one and a half stops will give the required detail in white areas. Bracketing of exposures is certainly warranted. At high altitude, there is a tendency toward excessive bluishness, and the use of a polarizing filter and a warming filter is highly desirable.

Safety is an important consideration in the mountains. The weather can change rapidly, and to prevent hypothermia, extra clothing and rainwear should be carried when hiking away from the car. Never hike alone, especially when venturing off the main trails. Wear sturdy boots to prevent ankle sprains on rocky or uneven terrain. Carry plenty of water. Mountain streams may look pristine

The Sneffels Range in autumn, San Juan Mountains, Colorado. *Minolta 70–210mm lens, polarizing and enhancing filters, Fuji Velvia film.*

Vivid autumn colors combined with interesting, snow-covered peaks can create exciting photographs. Backlighting or strong sidelighting always makes autumn leaves more colorful. The warm light near sunset adds to the impact of this image.

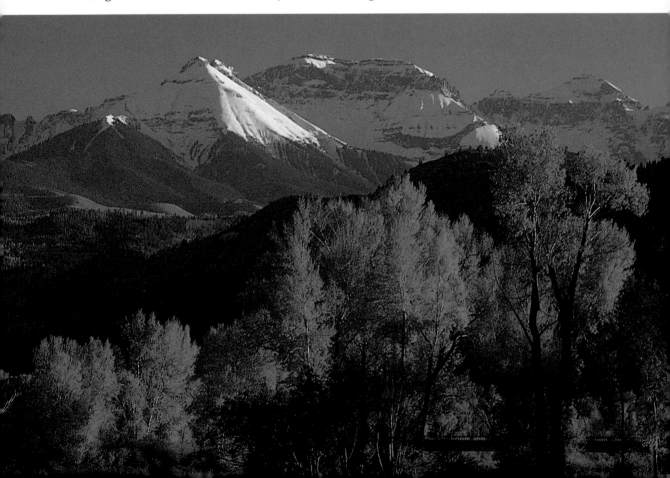

Tetons reflection, Grand Teton National Park, Wyoming. *Minolta 35–70mm lens, polarizing, enhancing, and Tiffen .3 graduated neutral-density filters, Fuji Velvia film.*

This beaver pond along the Snake River provides a beautiful foreground for the Tetons. I chose to include a large amount of foreground, which put the horizon near the top of the image. To balance the exposure between the scene and the reflection, I used a graduated neutral-density filter.

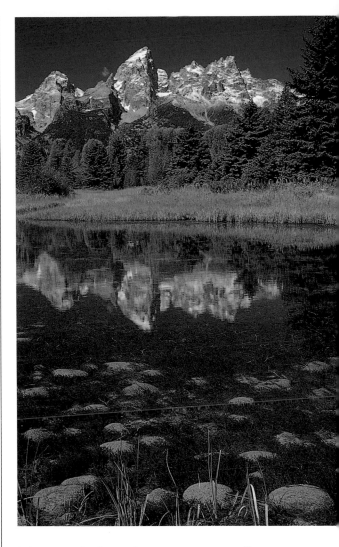

but often carry an organism called *Giardia*, which can cause intestinal disorders that may last for months. Never hike above timberline in stormy weather, to avoid the risk of lightning strikes. To protect your camera equipment from unexpected showers, carry a large Ziploc bag. A plastic trash bag can be used to protect your whole pack from precipitation.

Lakes

Lakes provide wonderful foregrounds for landscape photographs. But no matter how beautiful, lakes rarely produce memorable images without a more dominant subject as a center of interest, such as a mountain peak or beautiful trees.

Generally, lakes are most attractive when they include a reflection of the objects behind them. To prevent dividing scenes with reflections exactly in half, include foreground materials along the near shore of the lake. This will place the horizon closer to the top of the frame than to the bottom. A graduated or split neutral-density filter is usually needed to balance the exposure between the scene and its reflection. First meter on some object in the scene and then on its reflection. The difference in these two exposure readings will dictate which split neutral-density filter to choose. As a general rule, if sun is on the water, about one stop difference in density will be needed; if the

lake is in shadow, about two stops will provide the desired results.

On some occasions, photographs of reflections alone may produce interesting images. If the surface of the water exhibits slight movement, distortion of the reflected elements may yield intriguing abstract patterns.

Waterfalls

Waterfalls make strong centers of interest, with their light color, high interest value, and graceful form. The first decision you must make is how to interpret the scene.

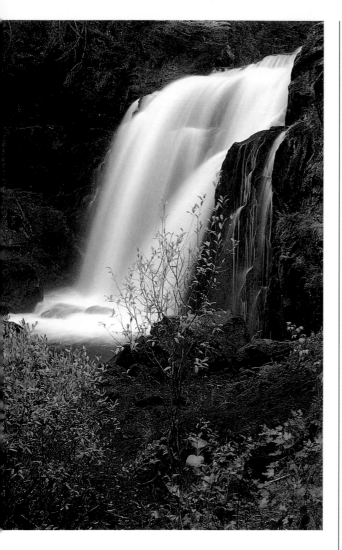

Moose Falls in autumn, Yellowstone National Park, Wyoming. *Minolta 35–70mm lens, polarizing and enhancing filters, Fuji Velvia film.*

This medium-size waterfall could be treated as either a graceful or a powerful waterfall. Since the day was overcast and the flow of water over the falls in the autumn was relatively low, I decided to blur the water and chose a shutter speed of ½ second. I used a polarizing filter to remove the reflection of the white sky on the autumn foliage.

There are two entirely different approaches, depending on whether the waterfall is graceful and lacy or powerful.

If the waterfall is delicate, then a slow shutter speed that blurs the water adds to the feeling of tranquillity. I normally use a shutter speed of ¼ to ½ of a second, which blurs the water but still preserves some detail. A slower shutter speed will make the water look like cotton candy. On overcast days, attaining this slow shutter speed is easy with ISO 50 to 100 films. Even when direct sunlight is on the falls, using a polarizing filter, neutral-density filter (not a split neutral-density filter), or even two polarizers at the same time will reduce the amount of light reaching the film and allow you to slow down the shutter speed enough to achieve the desired effect.

Large waterfalls, like Yosemite, Niagara, or Yellowstone Falls, are powerful and should be treated differently than a delicate cascade. A shutter speed of 1/30 to 1/60 of a second, which partially stops the water, will render these larger waterfalls very much as our eye sees them. Usually I try to photograph the more powerful waterfalls on sunny days and include a rainbow, if the angle of the sun at that time of the year makes it possible.

Streams or Rivers

Streams or rivers may be used either as a foreground compositional element or as the principal subject in the picture. As with waterfalls, the decision about whether to intentionally blur or freeze the water is an artistic decision that is up to you. If the stream is used as part of a scene, the success of the image will depend primarily on the strength of the center of interest in the background. To add strong compositional values to the picture, the portion of the stream or river you include ideally should be curved or strongly diagonal.

When used as the primary subject of the photograph, the stream should have inter-

esting form and also incorporate a well-placed cascade, interesting rock, group of flowers, or autumn foliage to serve as a center of interest. A slow shutter speed is very effective for close-ups of streams. If the stream is in shadow, the reflection of a colorful cliff or foliage that is in the sun may impart beautiful colors and patterns to the running water.

Trees and Forests

Trees and forests make excellent framing and supporting material, but they can also be used as the primary center of interest in the photograph. To qualify for this special recognition, the tree or trees should be unusually attractive or interesting in shape, size, or color.

Many deciduous trees are wonderful subjects throughout the year. In the winter, their bare branches and trunks provide strong patterns against the sky or snow. A group of sunlit trees will stand out beautifully against either a clear blue, polarized sky or a threatening sky. The exposure reading should be taken on the sunlit trees.

Bare trees, if interesting in shape, also make outstanding silhouettes in the fog or

Kokerboom Forest at sunrise, near Keetmanshoop, Namibia. *Minolta 70–210mm lens, enhancing filter, Fuji Velvia film.*

The kokerboom trees of the desert regions of southwestern Africa certainly make interesting silhouettes. I carefully composed this photograph so that the trees would not overlap. The large tree on the right is dominant in the picture and makes a good center of interest. The beautiful sunrise color completes the image.

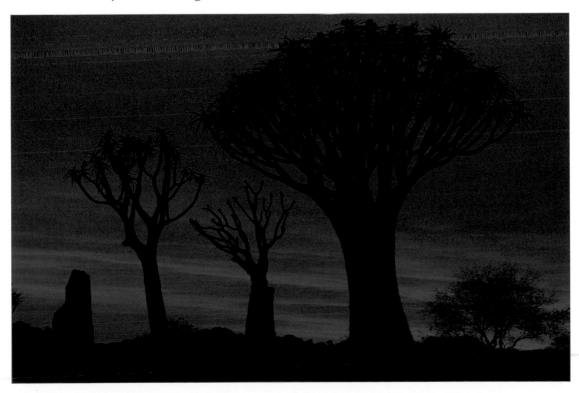

against the sky at sunrise or sunset. For silhouettes, the exposure reading should be taken on the sky. For sunrises or sunsets, expose at the meter reading obtained on the sky. With fog, open up a half to a full stop from the meter reading to achieve proper exposure.

In spring and summer, the green leaves of deciduous trees give a pastoral feeling to the landscape. In the autumn, their vibrant colors, when combined with other strong compositional elements, can yield stunning images. Aspen trees, found at the higher elevations of most of the western states, are one of my favorite subjects for autumn color, but maples, cottonwoods, oaks, and other deciduous trees found throughout the country make equally dramatic subjects. Backlighting or strong sidelighting will render the colors most vividly. The use of a polarizing filter and, especially, an enhancing filter will make the autumn colors even more brilliant.

Conifers can also make wonderful centers of interest. Redwoods and sequoias, due to their size and the color and character of their trunks, make powerful images. The size and majesty of these ancient trees may be conveyed by shooting upward along the trunk into the branches with a very wide-angle lens, or perhaps using a moderate telephoto lens to isolate a young tree against the trunk of one of these giants. Junipers and bristlecone pines, with their fantastic shapes, also make wonderful subjects. Evergreen trees bent by heavy snow are extremely interesting.

The rain forests, with their tremendous variety of trees, shrubs, plants, and mosses, provide a wealth of subject material. Overcast conditions usually are needed when photographing in rain forests to compress the contrast range enough to stay within the latitude of most films. Moderate telephoto lenses can be used to show forest detail such as mosses, fungi, mushrooms, fern patterns, and flowers. A wide-angle lens is useful in emphasizing foreground material. An enhancing filter is generally not needed in the rain forest, since green is the dominant color. A polarizing filter can be used to increase the saturation of all colors and to remove the reflection of the sky on forest vegetation.

Unusual lighting and weather conditions can add mood and provide the ingredients for wonderful forest pictures. Fog or haze may convey a feeling of depth in an image with trees in different planes. The strong silhouettes of tree trunks in the fog, penetrated by rays of sun, make for striking images. These spectacular situations may not last very long, so you must be able to quickly analyze and record the scene.

The Desert Southwest

The semiarid southwestern portion of the United States has a tremendous variety of beautiful and interesting photographic subjects. Each landscape photographer has a favorite area, and this is mine. I feel a kinship with this part of the country. I live there and go into the field as often as possible to photograph its many outstanding features.

The Colorado Plateau

Why do I enjoy landscape photography in this region so much? Two of the most important elements of any successful landscape

Capitol Reef near Grand Wash, Capitol Reef National Park, Utah. *Minolta 35–70 mm lens, polarizing and enhancing filters, Fuji Velvia film.*

The spectacular maroon cliffs of Capitol Reef are capped by buff sandstones. The light-colored cliff in the upper right is balanced by the strangely eroded sandstone boulder in the lower left. A dusting of snow in the gully adds interest. Late-afternoon light enhances the warm coloration of the rock.

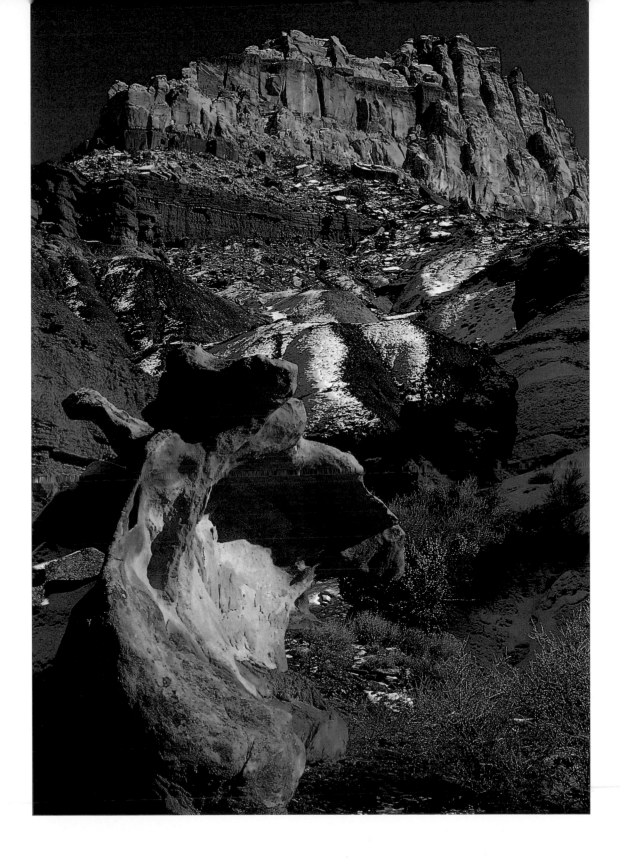

photograph are color and form. The Colorado Plateau, in my opinion, combines the two more effectively than any other area of the country, and perhaps the world.

The Colorado Plateau includes southern Utah, northern Arizona, southwestern Colorado, and northeastern New Mexico. The plateau is a high desert with elevations averaging about 5,000 feet. Many of the rocks in the plateau country are reddish due to a small amount of iron oxide deposited with the sediments. The rocks frequently exhibit

the strong, curved bedding patterns typical of eolian deposition. The gnarled juniper trees common in the canyon country are effective framing and compositional elements and add a great deal of interest to photographs of the area.

The seasons play an important role in the photographic opportunities in the red-rock country. Winter brings a blanket of snow to the higher plateaus such as Bryce Canyon and the rims of the Grand Canyon. Even at the lower elevations, snow usually falls several times during the winter, although it may not last very long. Snow on the red rocks gives even more sparkle and contrast to the spectacular landforms. Actually, snow enhances most other kinds of landscapes as well.

Springtime in the plateau country brings warmer temperatures and spring flowers. Though the flower displays do not rival the fields of flowers in the deserts of southern California and southern Arizona, wildflowers, cactus, and yucca add color and compositional elements to springtime images. The best technique for maximizing the impact of the flowers that are blooming is to use a wide-angle lens and take a camera position very close (3 feet or less) to a particularly attractive flower or group of flowers. This accentuates the size of the flower or flowers in the frame relative to the objects in the background. The use of hyperfocal distance in focusing is a necessity.

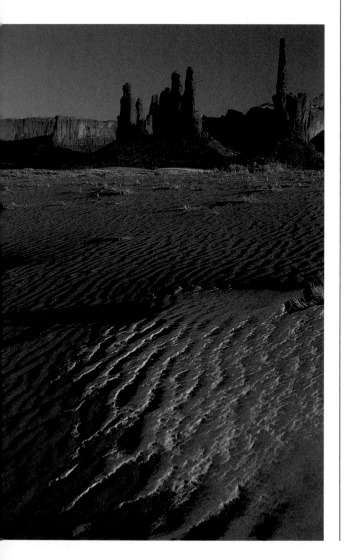

Totem Poles and sand dunes in winter, Monument Valley Tribal Park, Arizona. *Minolta 35–70mm lens, polarizing and enhancing filters, Fuji Velvia film.*
The Totem Poles are an example of the fantastic rock sculptures in Monument Valley. Ripple patterns in the maroon sand dunes that lie beneath the Totem Poles are best defined at sunrise and sunset. Snow falls several times each winter in Monument Valley, but it usually lasts only several days.

Summer is a good time to go to the mountains. During June, July, and August, the temperatures in the plateau country may regularly top 100 degrees F except at the higher elevations like Bryce Canyon and the north rim of the Grand Canyon. Small biting gnats appear in late May and usually last until mid-September at the lower elevations. If you can endure these adverse conditions, afternoon thunderstorms, common during the summer months, may provide you with some dramatic images of rainbows, lightning, and threatening skies.

The techniques for photographing rainbows and lightning strikes will be discussed later in this chapter. To photograph threatening skies, the exposure meter reading should be taken on other parts of the image, allowing the sky to go as dark as possible. If the meter reading includes the sky, the sky will be made less menacing and the entire image will be overexposed.

Autumn brings more pleasant temperatures to the canyon country. Although deciduous trees do not abound in this area, at the higher elevations, such as Bryce Canyon, Cedar Breaks, and the north rim of the Grand Canyon, aspen trees provide a brief burst of color at the end of September and early October. Cottonwood trees, found along many of the permanent streams, turn gold in late October and early November. The best autumn color can be found in Zion and Capitol Reef National Parks, and Canyon de Chelly National Monument.

To obtain spectacular photographs of the Colorado Plateau, the three most important factors are knowledge of the subject material, choosing the right time of day and year, and using the right combination of film and filters. Knowing exactly which arches, rocks, or spires will provide good centers of interest is vital. This knowledge comes only from firsthand experience, reading about the area, or talking to someone familiar with the area.

I do most of my photography in the plateau country as close to sunrise or sunset as possible. This will guarantee the best quality of light on the scene. Since I prefer to sidelight my subject material, I identify the time of year when the sun will rise or set at right angles to the direction I plan to photograph. Some features that are flatly lit at sunrise in June, for example, may be strongly sidelighted at sunrise in December. The secret is to return to good areas at different times of the year to get exactly the light and atmospheric conditions that make each scene most dramatic. This is equally applicable to most other landscape subjects, not just the plateau country.

The combination of filters and film chosen for photography in the Colorado Plateau is very important. Since reds, yellows, oranges, and maroons predominate in this region, you need film and filters that will record warm colors favorably. I have generally avoided making recommendations in this book about what kind of film to use, as personal preference plays a very important role. For the red-rock country, however, I strongly recommend Fuji Velvia film along with an enhancing filter. This combination renders reds as more beautiful than they actually appear in nature. The other key is a polarizing filter, which cuts through atmospheric haze and removes reflections from the rock, thereby saturating the color and darkening the sky.

Slot Canyons

Hundreds of feet deep and only a few yards wide, the slot canyons found in the plateau country were carved over millions of years by flood waters from infrequent but violent thunderstorms. Direct sunlight seldom penetrates into the depths of these convoluted gorges but bounces around on the walls, creating some of the most beautiful patterns imaginable.

Although slot canyons are found in several locations in the canyon country, the Page, Arizona, area contains some of the best. The slots around Page are located on the Navajo Indian Reservation, and permission must be obtained and a modest fee paid to visit them. When you visit the slot canyons, especially for the first time, it's best to go with a local guide. My favorite in

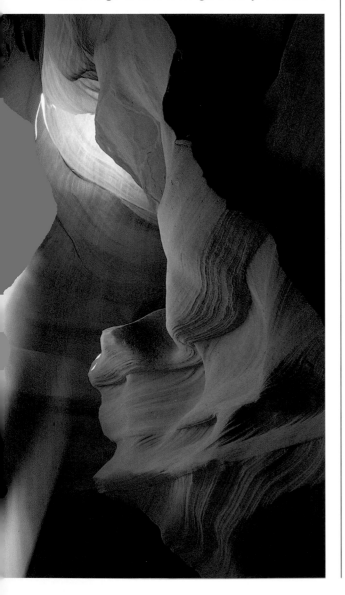

Page is Lake Powell Jeep Tours, 108 Lake Powell Blvd., Page, AZ 86040, telephone (520) 645-5501. Their rates are reasonable, and they have keys to the gates and permits from the Navajo nation to go into the slot canyons.

Ideally, you should choose a sunny day for a visit to the slot canyons. If the threat of thunderstorms exists, entering one of these deep, narrow gorges is potentially very dangerous. A cloudburst upstream could cause a flash flood and send a deadly torrent of water through the slot canyon. In 1997, eleven tourists were killed when such a flood swept through Antelope Canyon. In addition, the colors and patterns are much more saturated, vibrant, and textured when the sun is shining, even when direct sunlight doesn't enter the gorge. Contrary to the philosophy of lighting elsewhere, the best time to photograph in the slot canyons is at midday, when the sun is high in the sky. This allows direct sunlight to briefly penetrate these gorges in a few places. For the same reason, visiting the slots in the spring, summer, or autumn months is more rewarding than in the winter.

Different philosophies exist about how to compose patterns in the slot canyons. My theory is to include a wide range of brightnesses. I rarely include areas that

Sunburst in the Corkscrew, near Page, Arizona. *Canon 35–105mm lens, 81A filter, 8 seconds, f/16, Fuji Velvia film.*

Most of the time direct sunlight doesn't penetrate into the depths of Upper Antelope Canyon. But for short periods of time each day during the late-spring and summer months, shafts of light create dramatic lighting. This beam was made visible by throwing a handful of dust into the air just before the exposure.

are directly sunlit but usually choose as centers of interest areas that are the "first bounce" from direct sunlight. When properly exposed, these areas will be yellow, and other parts of the picture, where the bounce light is second, third, or fourth generation, will be shades of orange, red, and violet. I always try to enclose the bright portion of the image completely with darker material to keep the eye within the frame. I use focal lengths of 28 to 200mm, depending on the pattern, and look for strong leading lines as I would in other landscapes.

One way to obtain the right exposure in the slot canyons is to spot-meter an "average" area and use that reading for the median exposure. Another method is to use matrix (evaluative) metering and assume that an equal amount of light and dark areas will exist within the frame. Whichever method you choose, I recommend bracketing extensively to ensure that you obtain usable images. I normally hold my aperture constant at f/16 for good depth of field and bracket by changing my shutter speeds. If some fairly light areas are included within the frame, an average exposure may be about 8 seconds (assuming Velvia and f/16). I might bracket by using 4, 6, 8, 12, and 15 seconds.

I've used several types of film in the slot canyons, including Kodachrome and Ektachrome, but highly recommend Fuji Velvia for several reasons. Each film has different characteristics when used for exposures over a second or two. Some experience objectionable color shifts. Velvia's color is very consistent, even at long exposures. Velvia also has a relatively low reciprocity failure—the tendency of a film to deviate from a linear response in density because of changes in exposure. (With short exposures, the response to light is linear. For example, $1/4$ of a second at f/5.6 is equivalent

to $1/2$ of a second at f/8 or 1 second at f/11. However, the same shot at 2 seconds and f/16 would yield an image that is too dark, so the time might have to be increased to 3 seconds. As the time increases to 5 or 10 seconds, this deviation from a linear response to light becomes progressively greater.) Finally, some films have "milky" blacks, whereas Velvia has good, rich blacks that add apparent contrast. I do not recommend using an enhancing filter with Velvia in the slot canyons. I tried it once, and most of the colors wound up as shades of red.

In the slot canyons, you'll also need a steady tripod, a cable release, and a flashlight to illuminate the canyon floor and to check camera settings. Many of the compositions will involve pointing the camera upward at a very steep angle. To keep from getting a stiff neck, use either an angle finder or a tall tripod. Since the temperature in the slots is usually 10 to 20 degrees colder than the outside temperature, you may wish to take along a sweater or sweatshirt.

Sand Dunes

Sand dunes are one of my favorite photographic subjects. Ripple patterns change each day as the wind sculpts the dunes. At sunrise and sunset, the patterns of light and shadow change with each passing minute. Strong compositional lines are abundant. The form and impact of the final image are limited only by your own creativity.

The most important ingredients in a successful photograph of sand dunes are design and simplicity. The ability to isolate patterns on the dunes without including other distracting elements is crucial. The strong elements of design are visible only when the dunes are strongly side- or backlighted. It is imperative that photographs on the dunes be taken within an hour of sunrise or sunset. Look for curved, diago-

Death Valley dunes at sunrise, Death Valley National Park, California. *Minolta 35–70mm lens, polarizing and enhancing filters, Fuji Velvia film.*

This image was made at sunrise in Death Valley. Early or late light is crucial in obtaining maximum shadow detail and warm colors. I was drawn to this dune because of the beautiful curve and the well-defined ripples in the foreground. The image was reversed for presentation.

image that includes a dominant dune in the background.

Sandy areas are potentially hazardous to camera equipment. Strong winds are common in desert areas, and sandblasting of lenses and filters is possible. Airborne dust and sand can potentially enter the camera body when you change film or lenses—with disastrous results. Sand grains may get into the leg-locking mechanisms of tripods. Even if strong winds have not been a factor, I always carefully clean my equipment after a photographic session on the dunes.

Many of the principles of lighting and composition that I have articulated in respect to sand dunes can also be applied to other undulating terrains, such as farmlands, grasslands, meadows, or snow-covered fields. In this book, I will not be able to cover techniques for every specific type of landscape, but I trust that you will be able to apply the principles presented here to your own favorite subjects.

Ancient Ruins and Rock Art
The desert Southwest contains the remnants of an earlier civilization. The Anasazi, or "ancient ones," inhabited this area from about the time of Christ to 1300 A.D. It was not until the late 1800s that the relics of this

nal, and vertical lines to include in the photograph. It's difficult to visualize these patterns before the light is good. Be extremely careful where you walk, because you may ruin an area that may be of interest later.

I usually use telephoto lenses to isolate specific designs and patterns on the dunes. On many occasions, I intentionally exclude any sky from the image to better emphasize these patterns. But I also frequently use normal or wide-angle lenses to emphasize ripple patterns in the foreground of an

Holly Ruins, Hovenweep National Monument, Colorado. *Minolta 35–70mm lens, polarizing and enhancing filters, Fuji Velvia film.*

I had initially visited this remote archaeological site in May, when the direction of light at sunrise was too flat. I returned at sunrise in December, when the ruins were strongly side-lighted. The composition was carefully planned so that the highest tower in the upper left would be balanced by the larger tower in the lower right.

ancient civilization were discovered. Some of the most interesting ruins have been protected in national parks and monuments. Many have been scientifically excavated, stabilized, and partially restored. Today these sites are visited annually by millions of people who seek to learn about this ancient civilization.

A fascinating legacy of the Anasazi is the rock art found on canyon walls throughout this region. Rock art can be divided into two basic types: petroglyphs and pictographs. Petroglyphs were scratched or chipped into the rock walls. Pictographs were painted or drawn on the walls, using pigments derived from plants. Preservation of this rock art is usually best where an overhanging cliff protects it from the elements.

Telling the story of this ancient civilization photographically is both interesting and challenging. The combination of strong architectural forms and crumbling walls makes the pueblos and cliff dwellings excellent subject material. Strong compositional lines and patterns abound. The mesa-top dwellings are lit by the sun most of the day, making them relatively easy to photograph.

Cliff dwellings were usually constructed beneath overhanging rock walls and may be either partially or completely shad-

owed during most of the day. As with most landscape subjects, the best images are obtained near sunrise and sunset. The winter months are especially good for photographing cliff dwellings, since the sun is low in the sky most of the day. Although acceptable images may be taken when the structures are completely in shade, contrast and texture are usually lacking.

Petroglyph, Monument Valley, Monument Valley Tribal Park, Arizona. *Minolta 70–210mm lens, polarizing and enhancing filters, Fuji Velvia film.*

This petroglyph in Monument Valley has always been one of my favorites because of the grace of the figures and the compositional design and contrast of the slab of rock on which it was drawn. I attempted to position the camera parallel to the rock so that depth of field would not be a problem.

I find it more rewarding to concentrate on specific portions of a structure with a moderate telephoto lens than on a whole pueblo or cliff dwelling. Towers, kivas, windows, and doors make especially strong centers of interest. I always look for diagonal or curved lines, such as rock walls, ladders, or beams, leading to the center of interest. Under sunny conditions, there is a great deal of contrast between sunlit and shadowed portions of the structures, and exposures may be tricky. I recommend metering on the sunlit portions of the dwellings and opening up a half stop. Try to avoid compositions with large areas of deep shadow.

When photographing rock art, resist the impulse to include the whole panel in your picture. Instead, choose the most interesting figure or arrangement of figures, and concentrate on that. Since petroglyphs are usually inscribed on desert varnish, which is very dark, most photographs require some negative compensation for proper exposure. Pictographs are normally painted on lighter walls and require either positive compensation or no compensation at all.

The Sonoran and Mojave Deserts

The Sonoran Desert and the Mojave Desert are lower in elevation and considerably drier than the Colorado Plateau. The Mojave Desert, or high desert, covers parts of southern California, southern Nevada, and western Arizona. Below 3,000 feet lies the Sonoran Desert, which occupies most of southern Arizona, extreme southern California, and northern Mexico.

Autumn and winter in the southern deserts bring pleasant temperatures and occasional rains. If the winter has been wet, Joshua trees, Mojave yucca, and annual wildflowers may bloom near the end of March. Many smaller cacti and cholla bloom in April, and the larger cacti, such as the saguaro and organ pipe, bloom in May and June.

It is not known exactly what conditions produce a good flower year. There have been years when the total rainfall was 200 or 300 percent of normal, and yet the flower display did not live up to expectations. Some experts think that the timing of the rains is more important than the amount. Even if annual wildflowers are limited to small patches, using a wide-angle lens to emphasize the foreground will give the impression that the flowers are prolific. Cactus and cholla are more predictable bloomers than the annual wildflowers. To check on local flowering conditions, call the visitors center at Saguaro National Park, Organ Pipe Cactus National Monument, Joshua Tree National Park, or the Arizona-Sonora Desert Museum near Tucson.

Summer brings extremely hot temperatures to the southwestern deserts. Temperatures in excess of 110 degrees F are common. By August, a flow of moisture from the south, called the monsoon, brings daily afternoon thunderstorms and spectacular lightning displays to the deserts. Sunsets and sunrises are also unusually beautiful at this time of the year.

Joshua tree blossoms, Joshua Tree National Park, California. *Minolta 35–70mm lens, polarizing filter, Kodachrome 200 film.*

The Joshua tree is one of the plants that typify the Mojave Desert. Branches on mature trees are totally undisciplined and assume interesting configurations. The Joshua tree usually blooms in late March. For this photograph, I used a 35mm lens to accentuate the blossom in the foreground and the grotesque shape of the tree.

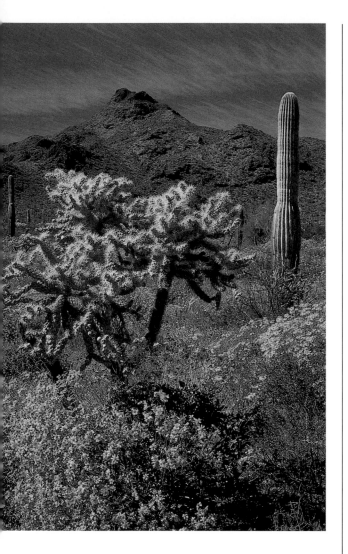

Whether blooming or not, the plants and landscape in the Mojave and Sonoran Deserts provide some wonderful photographic opportunities. The shapes of the saguaro cacti and Joshua trees are graphic, interesting, and often humorous. These large desert plants can be used either as a center of interest in the picture or as a framing element for a distant mountain range. As silhouettes, saguaros and Joshua trees make wonderful foreground elements for sunrises and sunsets, star trails, and lightning displays.

Desert in bloom, Organ Pipe Cactus National Monument, Arizona. *Minolta 35–70mm lens, polarizing and enhancing filter, Fuji Velvia film.*

The brittlebush in this portion of Organ Pipe Cactus National Monument was in prime condition. I used f/22 to obtain maximum depth of field. I chose this camera position to balance the cholla and mountain on the left with the larger saguaro in the upper right.

Backlighting is especially effective with cholla and the larger cacti, because their needles produce a halo of light around each trunk and branch. A dark background will accentuate this effect, but care must be taken to prevent lens flare. Strong sidelighting can be used to emphasize the texture of the ribs on the trunk and branches of the cactus. Close-up patterns of needles and ribs can be very interesting. Resist the impulse to include too many cacti and desert plants in the same image. A simple composition with no more than three main elements is usually best. As with most landscapes, the lighting will be most pleasing early and late in the day.

The desert is a beautiful place, but it's also a dangerous one. Temperatures can be extreme. The footing is rough and uneven, and everything in the desert tries to either stick you or bite you. However, with caution and common sense, most problems can be

Backlit Sonoran Desert, Organ Pipe Cactus National Monument, Arizona. *Minolta 70–210mm lens, enhancing filter, Fuji Velvia film.*

Backlighting in the cactus country is very effective because of the rimlighting that is caused by the long needles. The background is a mountain range that was still in shadow. Compositional balance was achieved by placing the saguaro cactus in the upper left and the organ pipe cactus in the lower right.

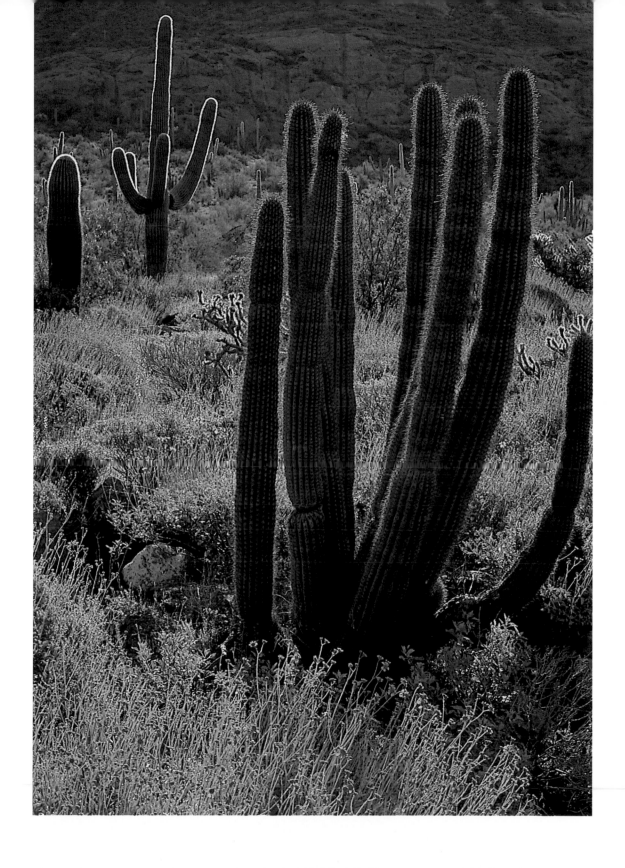

avoided. To prevent heat exhaustion or heatstroke, drink plenty of fluids, and carry water in your vehicle or on your person. Use sunscreen faithfully and wear a hat to avoid sunburn. Watch your footing carefully, and wear sturdy boots.

Cholla and cacti have sharp needles that must be avoided. The teddy bear cholla is probably the most dangerous. One careless moment can lead to extreme discomfort and inconvenience. Many other desert plants, including the ocotillo and paloverde, also have potent thorns that must be respected. I always carry a small pair of needlenose pliers in my photographic vest just in case. While rattlesnakes, scorpions, and Gila monsters are found in these desert areas, I seldom see any of them. Most snakes will make every effort to get out of your way. Stay alert, and don't put your hands in places you can't check visually first. Shake out your boots each morning, especially if you're camping. With a few sensible precautions, your visit to the desert will be safe and photographically rewarding.

Oceanscapes

As someone who was brought up in the Midwest and has lived in the Rocky Mountains my whole adult life, why am I so attracted to the ocean? One reason is the solitude I feel while walking along the beach, with the crashing waves drowning out the sounds of civilization. Another is the constant change brought about by weather and tides. Each wave is different. New and interesting objects are washed up on the beaches every day. I'm also attracted by the ocean's limitless power. The relentless waves have sculpted a landscape of rugged and picturesque beauty. And finally, I enjoy the many moods of the seacoast brought about by combinations of sun, wind, clouds, and fog.

Most of my oceanscape photography has been done along the Pacific coast, the Oregon coast in particular. The rugged sea

Saguaro patterns, Saguaro National Park, Arizona. *Minolta 70–210mm lens, no filters, Fuji Velvia film.*

This close-up of a saguaro cactus contains strong vertical, diagonal, and curved lines. Backlighting allows the center of interest to stand out from the trunk of the cactus. The carefully chosen camera position and tight cropping eliminated distracting material in the background.

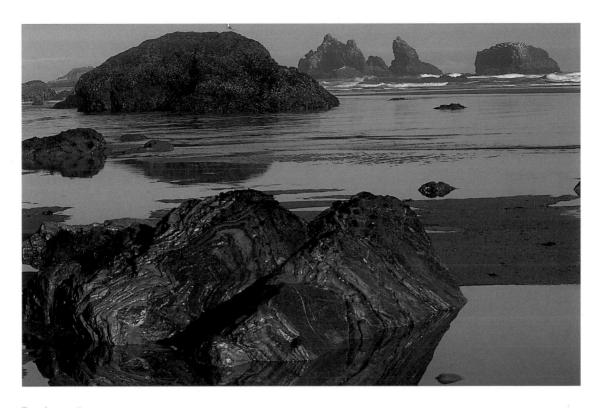

Rocks at Bandon Beach, Bandon State Park, Oregon. *Minolta 35–70mm lens, enhancing filter, Fuji Velvia Film.*

I had photographed on Bandon Beach many times but had never seen this large, beautiful red rock. It must have been buried beneath the sand and uncovered by erosion during a violent storm. The wet sand around the rock provided some beautiful reflections.

stacks that are common just offshore along the Pacific coast are rare along the east coast. I particularly enjoy photographing at locations where a large number of these offshore rocks are present. Depending on the time of day and atmospheric conditions, these stacks can be photographed separately or in combination. Most of the other oceanscape photography techniques presented in this section apply equally to other beaches throughout the world, including those along the east and Gulf coasts of the United States.

Recording the beauty and power of the ocean on film is challenging but rewarding.

Waves are perhaps the most difficult to capture because of their unpredictability. As the tide advances and retreats, the location where the waves are breaking the most violently also moves back and forth. I like to look for a rock or stack that appears to be catching every wave and then concentrate on it. The presence of other rocks, stacks, or headlands in the background also needs to be considered when choosing a camera position. Usually a moderate telephoto lens will be needed to make the breaking wave prominent in the frame. Since a shutter speed of at least $1/250$ of a second is needed to freeze the wave, con-

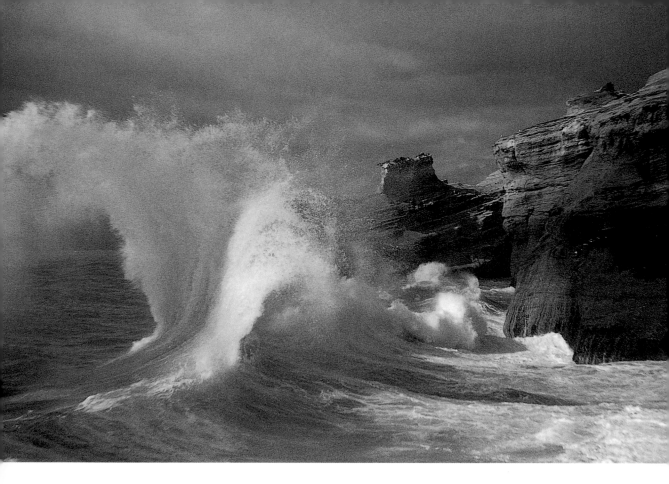

Surf at Cape Kiwanda, Cape Kiwanda State Park, Oregon. *Canon 35–105mm lens, polarizing filter, Kodachrome 200 film.*

Cape Kiwanda is perhaps the premier spot on the Oregon coast to photograph waves. The waves are funneled into a narrow bay, where they crash against the cliffs and then rebound and hit the next wave. This collision frequently produces a rooster tail that is spectacular to observe and photograph. BONNIE LANGE

sider using a fast film such as Provia (Sensia) or Kodachrome 200.

Photographs of waves when the sun is not out are usually disappointing. If the sun is out, sidelighting or backlighting gives the waves a feeling of translucence. I find that polarizing the image makes the color more beautiful. If a polarizer is used, fast film is a necessity. I usually take a large number of shots trying to anticipate which waves will be the most dramatic. Timing is critical, and a motor drive may help capture the precise moment. I bracket exposures in this situa-

tion, so I use a lot of film to get a few potentially outstanding images.

I love to walk along the beach at low tide and look for photogenic subjects in tidepools or on the sand. I usually wear sneakers so that I can get my feet wet, if necessary, and not ruin my hiking boots. As the water recedes, starfish and other tidepool creatures are temporarily exposed on rocks, where they can be easily photographed. Starfish are of primary interest, due to their striking shape and colors. I usually look for a red starfish to serve as a center of interest.

Additional starfish with less vivid colors in the same composition will give repetition of form without distracting from the center of interest. Other interesting subjects on the beach include kelp, driftwood, crabs, rocks, and shells.

My favorite time of day on the Pacific beaches is sunset. (I'm sure that sunrise on the Atlantic beaches is equally exciting.) As the sun slowly sinks into, or rises from, the bank of clouds and fog along the horizon, some magical moments may occur. But if photographs are taken when the sun is not sufficiently diffused, lens flare will be a problem. The rule of thumb is that if you can look at the sun without squinting, lens flare will probably not be a problem.

I try to pick an interesting offshore rock or group of rocks and place the sun in a strong compositional position relative to them. Wet sand reflects the color of the sun and clouds beautifully, so get as close to the edge of the ocean as possible. At sunrise or sunset, shutter speed is not a problem. Slow shutter speeds, which blur the waves, can enhance the mood of the image. The sky color reflected on the waves and beach can provide some outstanding images. I pre-

Starfish at low tide, Harris Beach State Park, Oregon. *Minolta 70–210mm lens, enhancing filter, Kodachrome 200 film.*

At low tide, starfish and other tidepool creatures are frequently left clinging to exposed rocks and make wonderful photographic subjects. The barnacles, anemone, and seaweed surrounding the two starfish add interesting supporting material. The red starfish is prominent in this image because of its color.

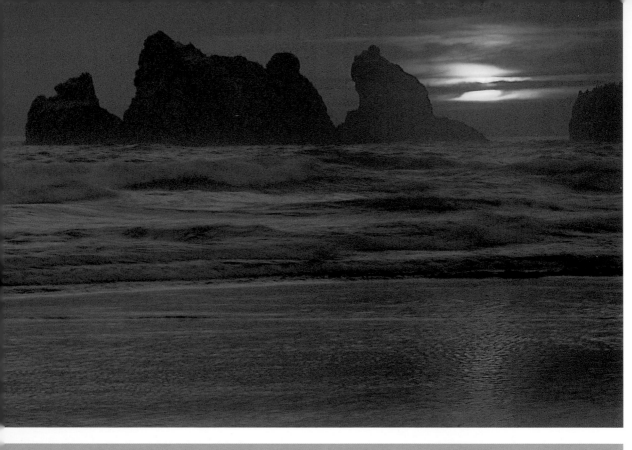

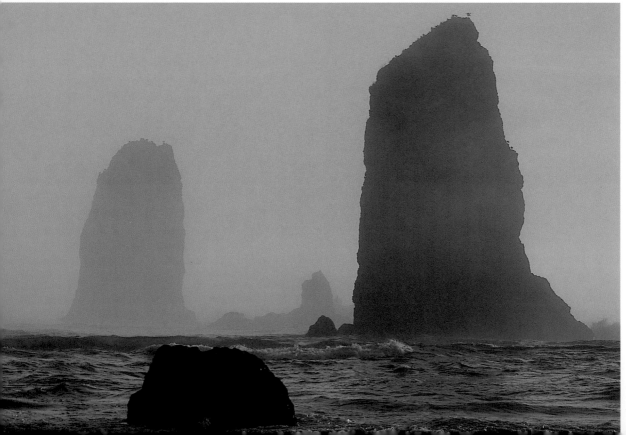

fer a film with enhanced color saturation, such as Velvia, for sunset or sunrise pictures. Enhancing filters may render all of the colors too red at these times of day and should be used with discretion.

Weather is the most important factor controlling the photographic opportunities along the Pacific coast. During much of the late autumn, winter, and spring, rain and wind are almost constant, and photography is difficult or impossible. In the wintertime, however, the waves are the most powerful, and a rare day of good weather may yield some dramatic images. In the summer, rain is less frequent and sunny days are common, though when the temperatures are hot inland, fog is pulled in over the shoreline and may limit photographic possibilities. Foggy conditions with offshore stacks at different distances can make for interesting images. Early autumn is one of the most pleasant times to visit the Pacific coast. Days are usually sunny, and the fog normally stays well offshore.

Sunset at Bandon Beach, Bandon State Park, Oregon. *Minolta 70–210mm lens, enhancing filter, Fuji Velvia film.*

I positioned myself at a location where the sun would set between the rocks in the background and be reflected on the ocean and the wet sand on the beach. As the sun sank into the low clouds along the horizon, it was diffused enough to eliminate lens flare. The slow shutter speed blurred the waves.

Fog and Needle Rocks, Cannon Beach, Oregon. *Minolta 70–210mm lens, enhancing filter, Fuji Velvia film.*

The fog in this image helps separate the offshore rocks. The rock in the foreground was positioned to balance the most prominent rock in the background. Since sunset was approaching, the fog took on a slightly orange hue, which was accentuated by the enhancing filter.

Great caution must be exercised along the seashore to protect both yourself and your equipment. Many of the slopes leading down to the beaches are steep and hazardous. The rocks at the shoreline may be wet and covered with slippery vegetation, and you need to maintain constant vigilance to ensure that waves will not pose a danger. This is especially important when the tide is coming in. Unusually powerful waves, called "sneaker waves," can catch the unwary by surprise and sweep them off the rocks.

I've taken my camera equipment onto the beaches many times without damage and will continue to do so. The potential rewards greatly exceed the risks involved. However, greater-than-normal hazards to equipment are present at the seashore, and you should always keep this fact in mind.

Salt water corrodes metal and wreaks havoc with camera electronics. The camera batteries usually short out and may burn up all the circuitry. If immersed in salt water, most modern cameras and lenses are a complete loss. The only slim chance for salvaging equipment exposed to salt water is to immediately put the affected items in a container filled with fresh water until they can be professionally repaired. Even the sea breezes are laden with salt, so you should gently wipe off the exteriors of cameras, lenses, and filters with a cloth moistened with fresh water after each shooting session. When changing film or lenses, use your body to shield your equipment from the wind-blown sand or possible salt spray.

Thermal Areas

Yellowstone National Park, in Wyoming, Montana, and Idaho, has the widest variety of hot pools, mud pots, travertine terraces, and geysers in the world. A few specific techniques apply to photographing these features.

Geysers are the most spectacular performers. The height of their eruptions ranges

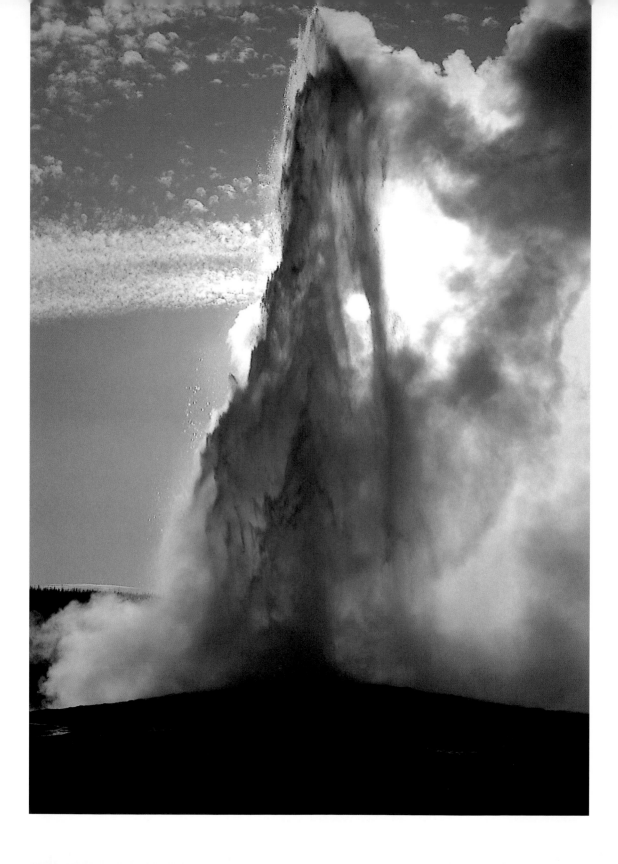

from several feet to more than 200 feet. Some erupt at very predictable intervals, and others are completely unpredictable. Some geysers erupt for only about a minute, and others may erupt for hours. Some erupt at an angle, and others have elaborate cones.

Successfully photographing a geyser takes planning, patience, and luck. Read pamphlets or check at the ranger station beforehand to see when the feature you hope to photograph is expected to erupt. Some of the eruption times for geysers are fairly predictable, such as for Old Faithful. Others can be predicted accurately only within two hours of the expected eruption.

Upon arriving at the geyser location, try to determine the direction of the wind. The most interesting portion of a geyser's eruption is the water that is projected from the opening. Steam is also a product of this eruption. The colder the temperatures, the more extensive the steam will be. The steam will be carried in the direction the wind is blowing. If that is toward the camera position, the steam will hide the column of water. I try to position myself somewhere upwind from the geyser so that the steam will be carried away from the geyser cone. Other considerations for choosing a camera position include the lighting direction, foreground compositional elements such as trees and runoff streams, and the background. I try to position the geyser off-center in the frame, leaving more room on the

side where I expect the steam to be carried by the wind.

Exposure on the column of water cannot be determined precisely prior to the actual eruption. The brightness of the water will usually cause underexposure if compensation is not applied. I normally choose a com-

Punch Bowl Spring, Yellowstone National Park, Wyoming. *Minolta 35–70mm lens, polarizing and enhancing filters, Fuji Velvia film.*

I always look for colorful runoff streams when photographing hot springs and geysers. A wide-angle lens was used to accentuate the amount of color in the foreground. I tried to take my pictures at the precise moments when the hot pool was bubbling to add interest.

Old Faithful Geyser at sunset, Yellowstone National Park, Wyoming. *Minolta 35–70mm lens, enhancing filter, Fuji Velvia film.*

I frequently try to photograph the last eruption of the day at Old Faithful. With backlighting, the water and steam assume an entirely different texture than under normal lighting conditions. Exposures are tricky because of the continual emergence and disappearance of the sun during the eruption.

pensation of plus one half stop and then bracket exposures.

Hot pools and terraces are much easier to photograph than geysers, although I usually wait until at least midmorning to photograph them. Steam, which may hide the thermal features, is a problem in the early-morning hours when the air is cold. Late spring, summer, and early autumn are the best times of the year to photograph these features, as dense steam in the winter months may make photography of pools and terraces difficult or impossible.

I look for beauty not only in the hot pools and terraces themselves, but also in the streams that carry hot water away from them. Colorful algae may grow in these runoff streams. The color is dependent on the temperature of the water, with greens and yellows in the hotter water near or in the pool, and oranges, reds, and browns in the cooler waters farther downstream. These runoff streams add compositional elements and color to the overall image. I often use wide-angle lenses to emphasize the patterns and colors of the runoff streams in the foreground of geysers or hot pools.

The geyser basins may provide some dangers for the careless or unwary. Stepping off the boardwalks to get a better composition is unlawful and may be dangerous. In some places the crust is very thin and a person could easily break through and be scalded. Steam will not harm filters and lenses, but water from the geyser eruptions carries a small amount of silica in solution. If geyser water falls on your filters and lenses, silica could be deposited on these surfaces and may be difficult or impossible to remove.

Patterns

Most of the photographs I take are "grand" scenics. That is my style. However, I also enjoy working with the smaller parts of the landscape—the patterns and abstracts. I was first introduced to this aspect of photography by Freeman Patterson in the mid-1980s at a seminar in Denver. That seminar opened my eyes to a new kind of photography. Freeman made a convincing argument that a successful pattern shot is just as interesting as a photograph of a larger scene. Looking for patterns in nature has added immeasurably to my enjoyment of photography.

Patterns are all around us in the natural world. The subject material can be quite large or very small. Ice, rocks, sand, water, leaves, and lichens are among the most often photographed subjects of pattern photographs. Some of the most important ingredients of a good pattern or abstract are strong design, good composition, repetition of form, and something to break the pattern and act as a center of interest. The appropriate lighting is also very important. Sometimes strong lighting is needed to accentuate the pattern; other times flat lighting works best. The sky is usually excluded from a pattern shot.

I usually use a moderate telephoto lens to record pattern shots. This allows me to come in tight on the most important part of the pattern and exclude distracting material from the background or around the edges of the image.

Frequently, a macro lens is needed to successfully photograph small patterns such as lichens, needles on a cactus, or bark patterns on trees. I prefer longer macro lenses in the 100 to 200mm range rather than ones

Rock and ice pattern, Churchill, Manitoba, Canada. *Minolta 70–210mm, enhancing filter, Fuji Velvia film.*

This rock covered with red lichens provides a strong center of interest. The camera position was carefully chosen to position the patterns on the ice diagonally and to eliminate other rocks that might have been distracting. Sunrise light gives warmth to the picture and texture to the patterns on the ice.

101

Slickrock pattern, Arches National Park, Utah. *Minolta 70–210mm lens, polarizing and enhancing filters, Fuji Velvia film.*

While waiting for the sunset at Delicate Arch one evening, I noticed a group of cross-bedded rocks below me that looked interesting. The dark shadows surrounding these rocks isolated them from the background. The largest rock, with the little bump on top, makes a good center of interest.

in the 50mm range. Longer lenses give more working room between the subject and the camera position. Many regular lenses have a so-called macro setting but usually do not focus as closely as a true macro lens.

If you wish to avoid the considerable expense of purchasing a macro lens, close-up lenses are a good alternative. These are attached like filters and allow your regular lens to focus at a closer than normal distance. Close-up lenses can be purchased in different strengths and can be used either separately or together to produce the desired range of focus.

Celestial Phenomena

Star Trails

Star trails are simply records on film of the seeming movement of the stars and planets across the sky with the passage of time. The stars are not actually moving, of course; their apparent movement is due to the rotation of the earth. However, the patterns are interesting and can make very effective images if some basic guidelines are followed.

The most important requirement is that the surroundings be as dark as possible. Choose a location far from city lights and

main roads. Do not open the shutter before the sky is totally dark, and close it before any hint of morning light. The sky should be basically clear, or the star trails will not be continuous. The best time of the month for photographing star trails is during the dark of the moon. If a partial moon is present, the shutter should not be open while the moon is above or near the horizon.

Leave the shutter of the camera open as long as possible. The longer the shutter is open, the longer the star trails will be. I regard three hours as a minimum length of time to record respectable star trails. Basic necessities are a sturdy tripod and a locking cable release.

Some modern electronic cameras are not suitable for extremely long exposures because they require battery power to keep the shutter open. For most of my star trail photographs, I use a mechanical Minolta XE-7, which is over twenty years old. It stays open as long as required, and if a dishonest person happens to find my camera during the night, or an animal comes by and knocks over my tripod, I haven't lost much of value.

The pattern of star trails that is recorded depends on what area of the sky appears in the photograph. If the North Star is included in the picture, the star trails will appear as concentric circles around it. If the camera is pointed to the east, arced lines dipping to the right will be observed. If the camera faces west, the result will be arced lines dipping to the left. In the Southern Hemisphere, the Southern Cross occupies a position in the sky near the South Pole, and stars appear to revolve around it. Hotter stars will be recorded as blue or white, cooler stars as yellow or red.

Star trails, by themselves, do not make very effective pictures. Use a strong silhouette of an object such as a tall cactus, a tree, a rock spire, or an arch in the foreground to add interest and compositional value. A variety of focal lengths can be employed, depend-

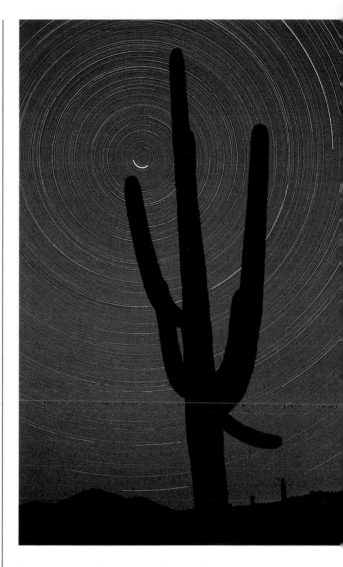

Star trails and saguaro, Organ Pipe Cactus National Monument, Arizona. *Minolta 35–70mm lens, no filters, 8 hours, f/3.5, Kodachrome 200 film.*

We spotted this saguaro near a gravel road that has almost no traffic at night. Since this cactus had character, it was a good candidate for a star trail picture. We positioned the cameras to place the North Star in the upper left portion of the frame. The shutter was open for about eight hours. BONNIE LANGE

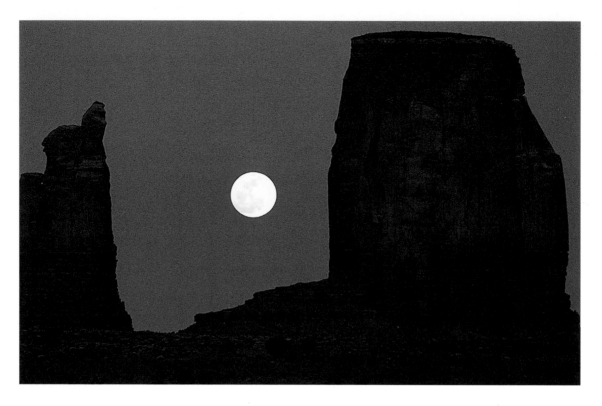

Moonrise, Monument Valley, Monument Valley Tribal Park, Utah. *Minolta 300mm lens, no filters, Kodachrome 200 film.*

I had seen the full moon come up at Monument Valley, but it didn't come up between the Mittens as I had hoped. We jumped in the car and raced to a different set of buttes where the alignment was better. With more time and better planning, I could have made a double exposure to make the moon larger in the frame.

ing on the proximity of the silhouetted object, but the image should include a preponderance of sky so that the star trails will be prominent. Since the maximum aperture of most of my zoom lenses is about f/3.5, I shoot star trails with the lens wide open. Those who use f/1.4 lenses may want to stop down a bit.

I recommend Kodachrome 200 slide film for star trails because, with its increased speed, it will record the fainter stars as well as the brighter ones. It also has a bluish film base, which makes the sky look very natural. All Fuji films and most E-6 Kodak films have a greenish base.

Moons

Photographs of the moon, by itself, are not very interesting; it needs to be included as part of a scene. This can be achieved in several different ways. The most authentic method is to photograph the moon and the landscape at the same time. Another technique is to sandwich a slide of the moon with a strong silhouette. A third method is to double-expose a moon and a scene on the same frame of film.

To really be an asset to a picture, the moon must be fairly large in the frame. A lens with a minimum focal length of 300mm should be

used, or the moon will be so small that it looks like a defect. If possible, use an exposure that will record detail on the moon's surface. I've found that the moon reflects one and a half stops less light than sunny 16 (see part 4). For example, with an ISO 100 film, 1/100 of a second at f/9.5 would be the approximate exposure. A relatively short exposure should always be used to photograph the moon, since it moves fairly rapidly across the sky.

Any photograph of the moon, whether taken with a scene or for sandwiching later on, must be taken at twilight or dawn when the sky is still light. If the sky is dark, the silhouette will not stand out against it. I find that the night before the official full moon is the best time to take photos that include moons. The moon, on that night, rises just after sunset, when plenty of light is still in the sky and afterglow may still be on the foreground.

Proper positioning prior to a moonrise is crucial, since the moon usually rises too rapidly to allow enough time to find a

Dust storm, Namib Desert, Namib Desert National Park, Namibia. *Canon 100–300mm L lens, enhancing filter, Fuji Velvia film.*

One morning in the Namib Desert, a dust storm obscured the sun, limited visibility, and made good images of the big, red sand dunes impossible. I found a group of dead acacia trees and decided to silhouette them with the rising sun. The dust diffused the sun, eliminating flare. This graphic shot rescued an otherwise slow morning.

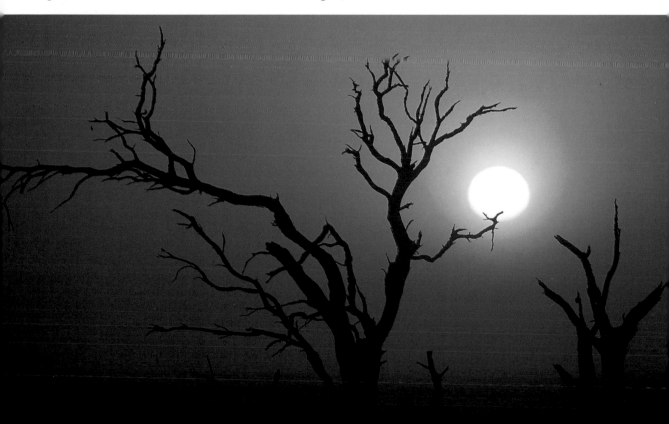

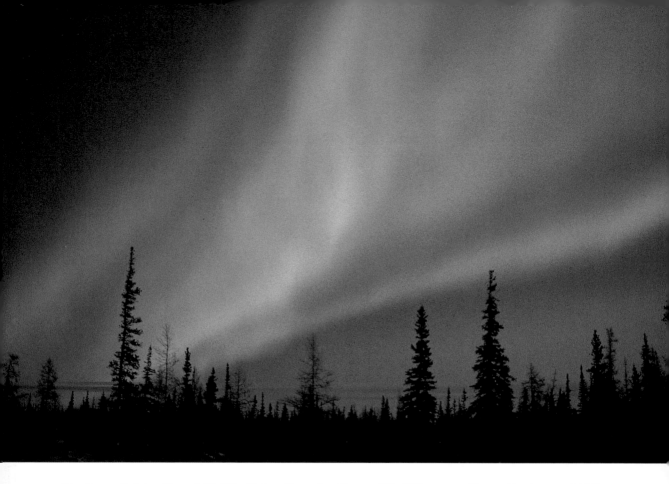

Northern lights, Churchill, Manitoba, Canada. *Canon 35–105mm, no filters, 5 minutes, f/4.5, Kodachrome 200 film.*

The night was clear, and the northern lights were beautiful. We drove along a back road into the forest, where the lights of town were far away and the pine trees provided an interesting foreground. I set my aperture as wide as possible (f/4.5) and tried exposures of 2 minutes and 5 minutes. In two hours, I made about twenty exposures before the aurora faded.

composition once it breaks the horizon. Computer programs are available that tell what time and in what direction the moon will rise, depending on the latitude and longitude.

If you include a moon by double exposure, make sure the image is believable. If the light on the scene is from the side, the laws of nature dictate that the moon cannot be full. If the scene was obviously taken with a wide-angle lens, a 600mm moon is inappropriate.

The Sun, Sunrises, and Sunsets

Unless diffused by fog, clouds, dust, atmospheric haze, trees, or smoke, the naked sun will cause lens flare. A long focal-length lens should be used so that the sun will be as large as possible in the frame. Take your exposure reading on the sky away from the sun. When photographing sunsets or sunrises without the sun, take your meter reading on the sunlit clouds. An interesting foreground silhouette is mandatory, whether the sun is included in the image or not.

To obtain a sunburst effect with the sun, without using a starcross filter, a pinpoint of light is required. This may occur just as the sun breaks the horizon, peeks around a spire, or emerges from behind a tree or tall cactus. Too much sun will cause lens flare. Continual adjustment of the camera position may be required as the sun moves, to keep the light at just a pinpoint. Use your smallest possible aperture (f/22 or f/32). The starburst is caused by the interaction of the pinpoint of light with the blades of the diaphragm of the lens.

Lightning

Photographs of lightning can be very dramatic. Sheet lightning does not usually produce good results—bolts of lightning are needed. Although lightning storms may occur during daylight hours, timing the bursts precisely enough to record them on film is extremely difficult. I prefer photographing lightning at night and leaving the shutter open until several bursts are recorded on each frame. A sturdy tripod and cable release with lock are mandatory. I usually photograph lightning with the lens wide open.

Safety is an extremely important consideration when photographing lightning storms, for obvious reasons. If the storm is close, not only will you be in extreme danger, but rain, wind, or hail may damage your camera and lens as well. A storm that is 10 to 20 miles away will provide good lightning strikes and should not cause risk to you or your equipment. As with other celestial phenomena, lightning photographs are most effective when combined with strong silhouettes, such as saguaros, trees, balanced rocks, arches, or spires.

Northern (or Southern) Lights

These interesting phenomena are caused by the magnetic field of the earth and are most brilliant near the magnetic North and

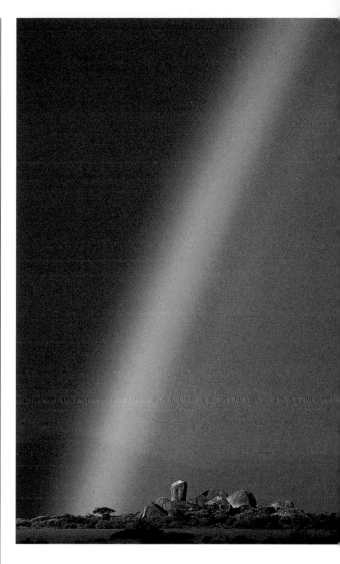

Rainbow in Namaqualand, Cape Province, Republic of South Africa. *Canon 100–300mm L lens, polarizing filter, Kodachrome 200 film.*

A rainbow is usually a fleeting phenomenon, but this rainbow lasted for nearly an hour. I used a 300mm lens to concentrate on the most brilliant portion of the rainbow and emphasize the granite koppie in the middle distance. The polarizing filter made the rainbow even more colorful.

107

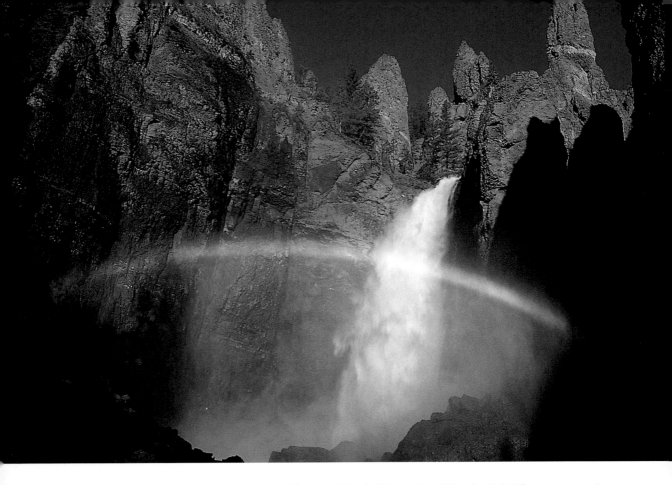

Tower Falls and rainbow, Yellowstone National Park, Wyoming. *Minolta 24–35mm lens, polarizing and enhancing filters, Fuji Velvia film.*

Rainbows can add tremendous impact to photographs of waterfalls. When photographing close to any waterfall, the mist that creates the rainbow may also dampen the lens. I always carry a soft cloth in my photo vest in case I need to dry off my lens or filters between exposures.

South Poles. In the Northern Hemisphere, the winter months provide the best displays. The aurora changes constantly, so no two photographs will be exactly alike. As when photographing star trails, a location away from city lights is required, and a clear, moonless night is best. A sturdy tripod and cable release are mandatory. Since a maximum of several minutes of exposure is normally required, most camera bodies will work satisfactorily. Outside temperatures may be brutally cold, and it's important to keep your camera body warm before making the exposures.

Foreground silhouettes such as evergreen trees add interest to the picture. Fast film, such as Kodachrome 200, is highly desirable. Push processing is a viable option. Exposures are variable, since the light emanating from the aurora is inconsistent. A fast (f/1.4) lens requires a much shorter exposure than a slower (f/3.5) lens. Shutter speeds of 5 to 10 seconds can be employed with ISO 200 film and an f/1.4 lens, whereas 1 to 3 minutes may be required for an f/3.5 lens. It's good to bracket your exposures widely. Normal and wide-angle lenses are more useful than telephoto for photographing the aurora.

Riverside Geyser and rainbow, Yellowstone National Park, Wyoming. *Minolta 35–70mm lens, polarizing and enhancing filters, Fuji Velvia film.*

Since Riverside Geyser was scheduled to erupt about an hour before sunset, I knew that a rainbow would develop. I chose a camera position and waited for the eruption. When it came, I adjusted my camera position slightly and used my polarizing filter to make the rainbow more vivid.

Rainbows

Rainbows are one of the most beautiful elements that can be included in scenic photographs. Rainbows associated with thunderstorms are often unpredictable and transitory, but those produced by waterfalls and geysers are more predictable and may last longer.

The position of rainbows follows the laws of optics. Several elements are mandatory. The sun must be somewhere behind the camera position, and water drops or mist must be in front of the camera position. Under these conditions, a rainbow will appear at a prescribed angle in front of the camera. A rainbow has two limbs; if possible, use the one that works best compositionally with your subject. An extremely wide-angle lens is required to record both limbs of the rainbow simultaneously.

You may have the good fortune of arriving at a waterfall during the time of day when a rainbow is visible. Often this rainbow will last for at least fifteen minutes as it moves across the falls in response to the movement of the sun.

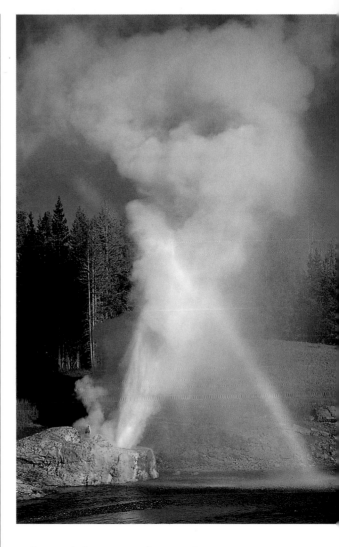

Any rainbow can be made even more vivid by the proper use of a polarizing filter. If the polarizer is oriented at the wrong angle, however, the rainbow can be completely eliminated. When using a single-lens reflex camera, obtaining the proper orientation should not be a problem.

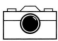

Preparation and Attitude

Photography should be fun. For those of us who make a living taking photographs, it's a job. But for most photographers, the only good reason for taking pictures is the enjoyment they derive from it. This means finding the level of involvement with photography that makes you happy. Total dedication to photography takes more time and energy than most people have, given the constraints of a job and family. Nevertheless, you can visit interesting places on weekends or on your vacation and enjoy the experience of photographing beautiful landscapes. As your skills improve, you will return with artistic images that help you recall those wonderful moments.

Preparation

In order to make the most of any photographic outing, thorough preparation is necessary. Most of these suggestions are just good common sense. If you are visiting a location for the first time, do some research so that you will, at a minimum, have a feeling for the topography and geography of the area before you arrive. Libraries, bookstores, and travel agencies are good places to find information locally. Many tourist destinations have visitors bureaus that will be happy to send you information. If you're planning to visit a national park or monument, brochures are available to help you plan your visit. Looking at coffee-table photo books may give you some ideas about where to find the most photogenic locations. Chatting with another photographer who has visited the location can be very helpful.

Quite a few people solve the problem of finding locations by joining photographic workshops and using the knowledge of the leaders to guide them to the best spots at the proper times. Before joining a workshop, be sure that the leader is thoroughly knowledgeable about the specific areas you want to visit. The leader may be a wonderful photographer, but if he or she has little or no experience in that particular area, many good photo opportunities are likely to be missed. Examine the credentials of any potential workshop leader carefully. Many leaders knowingly inflate or misrepresent their true qualifications to get your business. Some leaders are primarily wildlife photographers and have little enthusiasm for, or expertise in, landscape photography. Don't be bashful about asking for references. If a company has been in business for quite a few years, it must be doing something right.

The best way to improve your artistic skills is to do as much photography as possible between major outings and realistically analyze the results in regard to composition, lighting, and exposure. Having experienced photographers view and comment on your

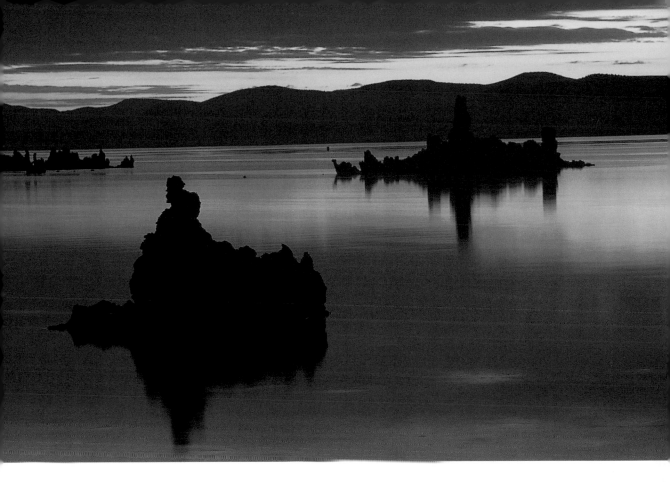

Mono Lake at sunrise, California. *Canon 35–105mm lens, enhancing filter, Fuji Velvia film.*
 Mono Lake is famous for its picturesque tufa towers and beautiful sunrises. It lies on the eastern side of the Sierras, across Tioga Pass from Yosemite. We left Yosemite at 3 A.M. so that we could be at Mono Lake at dawn. The colors were made even more spectacular by the use of Velvia film and an enhancing filter.

work may also be helpful. Studying books such as this one should also help you improve your skills.

Before setting out, you need to have a basic knowledge of how to operate your camera. Some of the most important functions are bracketing exposures, understanding how the metering system works, and knowing how to control depth of field. Practice is the only way to become comfortable with these important operations. You should determine what ISO is correct for your camera body by shooting some test shots on average subjects. Keep your instruction booklet handy in case you need to employ some of the camera's seldom-used functions or for troubleshooting.

In most areas, some walking or hiking is required to maximize your opportunities. Physical capabilities vary, but by walking several miles a day, three days a week, most persons would be in good enough shape to reach the photographic locations shown in this book. If you're in doubt about what level of exercise is appropriate for you, check with your physician.

Having the proper footwear and clothing on your photographic outing is extremely

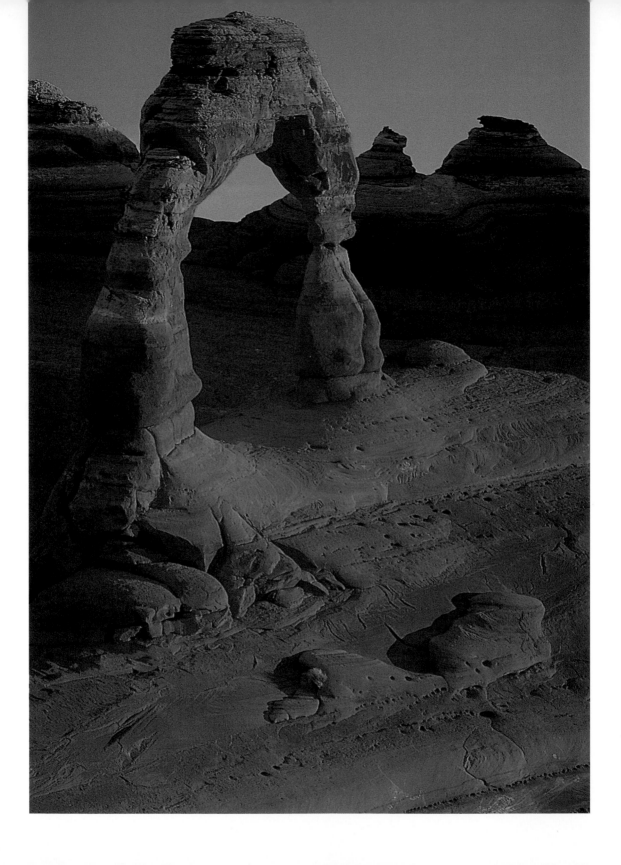

important. Comfortable, well-broken-in hiking boots are essential. Boots should be high enough to provide good ankle support and have a lug sole for secure footing on trails, rocks, or snow. Consider wearing two pairs of socks: one thin inner pair and a heavier outer pair. This will help prevent blisters, cushion your feet, and provide additional warmth in cold weather.

What clothing you should take on an outing depends on the location and time of year. Conditions may change quickly and dramatically, especially in the mountains. Layered clothing is best. As the temperature rises or falls during the day, comfort can be maintained by adding or subtracting layers, such as sweaters, sweatshirts, or light jackets. A windbreaker will help keep the wind from penetrating the layers below. A knit hat and gloves will keep your extremities warm. A hat with a brim should be used in sunny weather for protection from the sun.

Always put safety first. Don't place yourself in situations where a substantial possibility of danger exists. An injury will certainly limit or terminate your photographic outing. If hiking off the beaten path, go with another person or make sure someone knows where you are going and when you plan to return. Always carry enough water for the period of time and season of the year you plan to be in the field. Carry a small first-aid kit in your photo pack or vest.

Delicate Arch at sunrise, Arches National Park, Utah. *Minolta 70–210mm lens, polarizing and enhancing filters, Fuji Velvia film.*

Delicate Arch is the symbol of Arches National Park. It attracts a lot of people, especially at sunset, many of whom like to stand in the arch or sit all over the rocks near the arch. At sunrise in the winter, however, equally desirable lighting conditions exist, and no one else is around to spoil the experience or the image.

Attitude

I've found over the years that proper attitude plays a major role in achieving good results. Every successful landscape photographer must have a combination of patience and determination. I am basically not a patient person, but I make up for it by being extremely determined. The landscape photographer must be willing to accept the fact that the weather conditions will not always be ideal. Sometimes entire days are lost because of inclement weather. Cold, heat, wind, or insects may cause physical discomfort. A meal may be missed or delayed. Tolerance for such inconveniences varies greatly among individuals, but if any possibility exists that the atmospheric conditions will improve, your patience and determination to stay at a good location will often be rewarded. No great photographs were ever taken from a motel room or a restaurant.

I'm usually willing to sit and wait for hours, if necessary, for the clouds to break or for the lighting to improve. One advantage of staying at a particular location for a long time is the opportunity to really enjoy the beauty of the scene. If the weather is ideal and I arrive at a location, photograph it quickly, and leave, I usually don't take the time to really appreciate it.

I prefer to be completely alone when photographing landscapes. Waiting for the definitive moment is usually difficult with a nonphotographing companion. Either the photographer feels guilty about making the other person wait or the companion becomes impatient. Also, good landscape photography requires total concentration, and the conversation or questions of a companion, no matter how well intentioned, can be distracting.

One discipline that is difficult for many people is getting out of bed early enough to be in the field ready to photograph at sunrise. A "morning person" finds this much easier than an "evening person." Sunrise

113

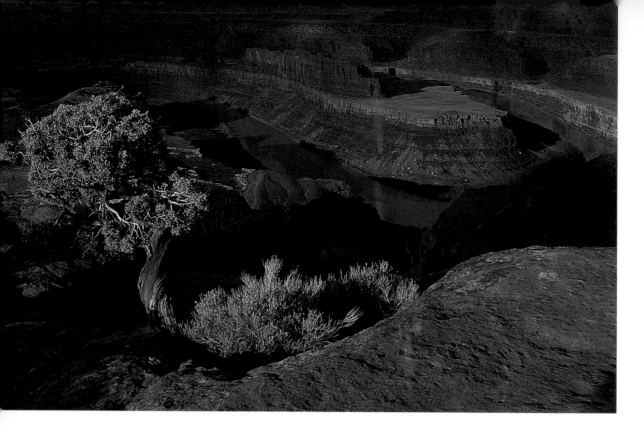

The Colorado River from Deadhorse Point, Deadhorse Point State Park, Utah. *Minolta 35–70mm lens, polarizing and enhancing filters, Fuji Velvia film.*

I've photographed this scene many times. On one occasion the sky was mostly cloudy. But for about a minute, the sun lit up the bend of the river and my foreground framing while the remainder of the scene was in shadow. These spotlighting conditions have produced my favorite image of this scene.

photography is important for two reasons. If the weather is favorable, sunrise is one of the two times during the day when the quality of light is best. Also, very few people or photographers are in the field at sunrise. Most are still in bed. This means that you will have little problem with people in the way of the feature you want to photograph or obtaining the exact camera position you want. Often I am returning from a morning hike or shooting session before I see another person. I like it that way.

The desire and ability to return to areas that offer outstanding subject material are very important for successful photography. No one can take full advantage of all the photographic opportunities in an area on one trip. The change of seasons brings different atmospheric conditions and different lighting directions at sunrise and sunset. I have photographed in Arches National Park at least a hundred times and the Grand Tetons and Yellowstone more than seventy-five times. I still visit these productive locations whenever possible, because I know that I'll be able to find new and exciting compositions and perhaps improve on scenes I've previously photographed. I also identify compositions that I'd like to photograph on future visits. I don't need much of an excuse to return to these and other beautiful locations, again and again.

A Joseph K. Lange Portfolio

Some of my favorite photographs have interesting stories behind them, and many of them also teach important lessons. This photograph was made in Colorado at the Great Sand Dunes. When I visit any dunes area, I try to avoid locations where other people have walked and tracked up the sand. I often walk parallel to the dunes about a half mile from the parking area before going into them. I try to arrive before the sun comes up in the morning, or at least two hours before sunset, to try to identify good potential compositions. The magic light does not last long, and decisions must be made quickly.

On the afternoon this image was exposed, the wind was howling and the sand was blowing around. I tried to keep my camera protected inside my pack until I was ready to start shooting. As the sun sank toward the horizon, shadows lengthened and strong

Sandstorm patterns, Great Sand Dunes National Monument, Colorado. *Minolta 70–210mm lens, polarizing filter, Kodachrome 200 film.*

patterns began to emerge. I find S curves particularly intriguing. I intentionally eliminated the sky and waited until the large dune in the background was completely dark so that nothing would distract from the dune pattern. The sand ridge leads the eye from the lower left and around the curve to the center of interest in the upper right. The blowing sand helps tell the story. The exposure reading was taken on the sunlit area of the dune.

Doorways, Pueblo Bonito, Chaco Canyon National Historical Park, New Mexico. *Minolta 70–210mm lens, enhancing filter, Fuji Velvia film.*

Chaco Canyon National Historical Park, in northern New Mexico, contains some of the best preserved and most interesting Anasazi ruins in the desert Southwest. I had seen other shots of these doorways in Pueblo Bonito and decided to look for one of my own. The people who built these pueblos must have been very small, because I had to negotiate several of the openings on my hands and knees.

Exact positioning of the camera was critical so that all of the doorways would be visible. I chose a telephoto lens to make the bright wall at the end of the passageway as large as possible. To obtain the depth of field required, I photographed this scene at f/32 at a shutter speed of about 2 seconds.

I have visited the Maroon Bells near Aspen, Colorado, at all seasons of the year. In early summer, dandelions cover the meadows below the Bells. In autumn, the golden aspens frame the Bells and are reflected in the small lake at their base. In winter, the steep, narrow road to the Bells is closed, and avalanches regularly crash into the narrow valley that provides access. But for those willing to cross-country ski about 15 miles round-trip, the pristine, snow-covered peaks are an awe-inspiring sight.

The first time we skied into the Maroon Bells in the wintertime, the weather was perfect. We started up the trail before dawn, anticipating about a four-hour trek into the Bells. We reached Maroon Lake, which is mostly frozen in the wintertime, at mid-morning, the time of day when the lighting on the peaks is optimal. I noticed a curving pattern on the ice of the lake and knew it would provide an outstanding foreground. I chose a camera position from which the pattern would lead up to the peaks in the background. Then I took a meter reading on the scene and opened up about a stop and a half. This has been one of my most successful images. It's been used for posters, postcards, numerous advertisements, and the cover of the Yellow Pages in Denver.

The Maroon Bells in winter, White River National Forest, Colorado. *Minolta 35–70mm lens, polarizing filter, Kodachrome 64 film.*

Rising up from dark volcanic rocks on ridges and volcanic slopes in Namibia and western South Africa are the kokerboom trees. These rare and grotesque trees have massive trunks and can withstand years of drought. The Bushmen natives hollow out the branches to make quivers to hold their arrows, hence the common name "quiver tree." Near the old German town of Keetmanshoop in southern Namibia, a particularly large concentration of these interesting trees has been set aside as a national preserve. We visit the kokerboom forest each year on our workshops in southern Africa.

Over the years, I've tried just about every compositional possibility with the kokerboom trees. I've photographed groups of trees together, lain flat on my back and shot upward along the trunk with a wide-angle lens, and used the trees as silhouettes at sunrise and sunset. One of my favorite images uses the trunk of one kokerboom to frame several others in the background. I had to set up my camera quite close to the foreground tree to keep from cutting off the trees in the background. I framed the image so that no bright areas were visible outside the trunk on the edges of the frame. To obtain the depth of field required, I shot at f/22 at the hyperfocal distance. I waited until close to sunset to take this picture so that the light would be as warm as possible.

Kokerboom trees, near Keetmanshoop, Namibia. *Minolta 35–70mm lens, polarizing and enhancing filters, Fuji Velvia film.*

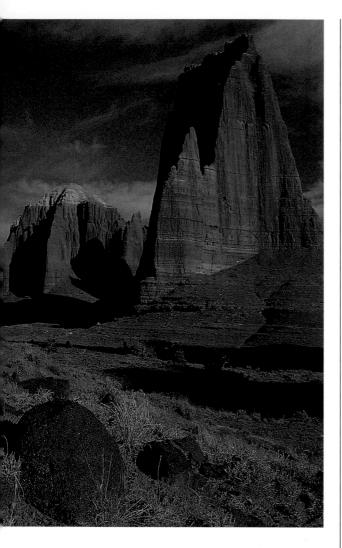

Cathedral Valley, Capitol Reef National Park, Utah. *Minolta 35–70mm lens, polarizing and enhancing filters, Fuji Velvia film.*

Capitol Reef National Park, in south-central Utah, features colorful cliffs, rugged canyons, massive domes, soaring monoliths, and graceful natural bridges. Because of its remote location, it does not attract as many people as Bryce Canyon, Zion, or Arches National Park. Cathedral Valley, in the northern portion of Capitol Reef, can be reached only by vehicles with high clearance or four-wheel drive.

I searched for quite a while before finding this composition. I wanted to use a picturesque juniper tree to frame the cathedrals, but I couldn't find one that really worked with the scene. I decided to use a large volcanic boulder for foreground material instead. I positioned the camera so that the rock was in the lower left, balancing the prominent butte in the upper right. High cirrus clouds make the sky more interesting.

The Canadian Rockies are an alpine paradise, with snow-capped peaks, thundering waterfalls, sparkling glaciers, and turquoise lakes. In summertime, gardens of wildflowers cover the slopes. Moraine Lake, in Banff National Park, lies at the head of a glacial valley surrounded by rugged, glacially carved peaks. A particularly good view can be obtained from the top of the moraine that rises above the outlet of the lake. Reflections always create impact but must usually be photographed early in the morning before the wind starts to blow. The group of trees in the lower right was used to balance the dominant peak in the upper left. A .6 Tiffen graduated neutral-density filter was used to even out the exposure between the shadowed lake and the sunlit portion of the mountains. A few puffy clouds added some character and color to the sky at sunrise.

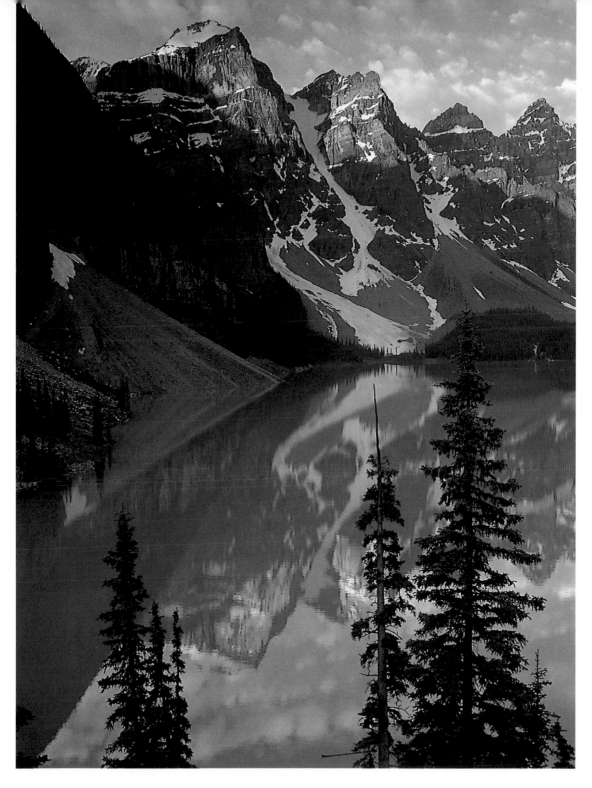

Moraine Lake at sunrise, Banff National Park, Alberta, Canada. *Minolta 24–35mm lens, polarizing, enhancing, and Tiffen .6 graduated neutral-density filters, Fuji Velvia film.*

Erosional patterns, Zabriskie Point, Death Valley National Park, California. *Minolta 70–210mm lens, polarizing and enhancing filters, Fuji Velvia film.*

Death Valley National Park is a mecca for photographers who enjoy working with patterns and abstracts. Dried-up salt lakes, sand dunes, mud cracks, erosional patterns, rock formations, and desert plants provide unlimited opportunities. The pattern seen on this eroded mudstone slope near Zabriskie Point is extremely interesting and colorful. Strong, early-morning sidelighting makes the diagonal lines powerful compositional elements. A telephoto lens was used to concentrate on the most interesting part of the pattern.

The Island-in-the-Sky District of Canyonlands National Park rises 2,000 feet above the Colorado and Green Rivers and provides some awe-inspiring views of the plateaus and canyons below. The Green River Overlook is one of my favorite locations in Canyonlands because of its expansive vistas and the amount of interesting framing material available.

Perhaps my favorite image from Green River Overlook was taken after a heavy snowfall on the canyon rims. I used a wide-angle lens to accentuate the form and color of the rocks at the edge of the canyon. The camera position was precariously close to the edge of the 1,000-foot-high cliff but was necessary to obtain the perspective I wanted on the foreground rocks. I have made two other interesting images at Green River Overlook, using gnarled junipers and golden grasses for foreground framing.

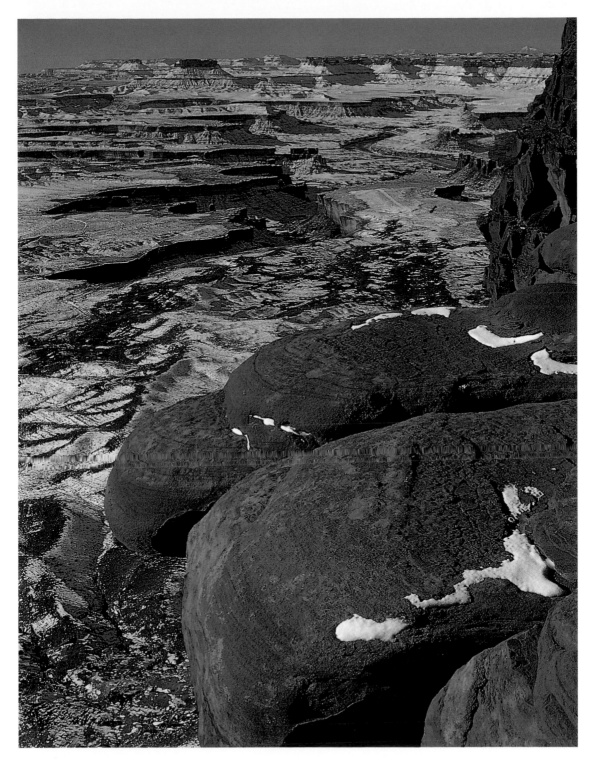

View from Green River Overlook, Canyonlands National Park, Utah. *Minolta 35–70mm lens, polarizing and enhancing filters, Fuji Velvia film.*

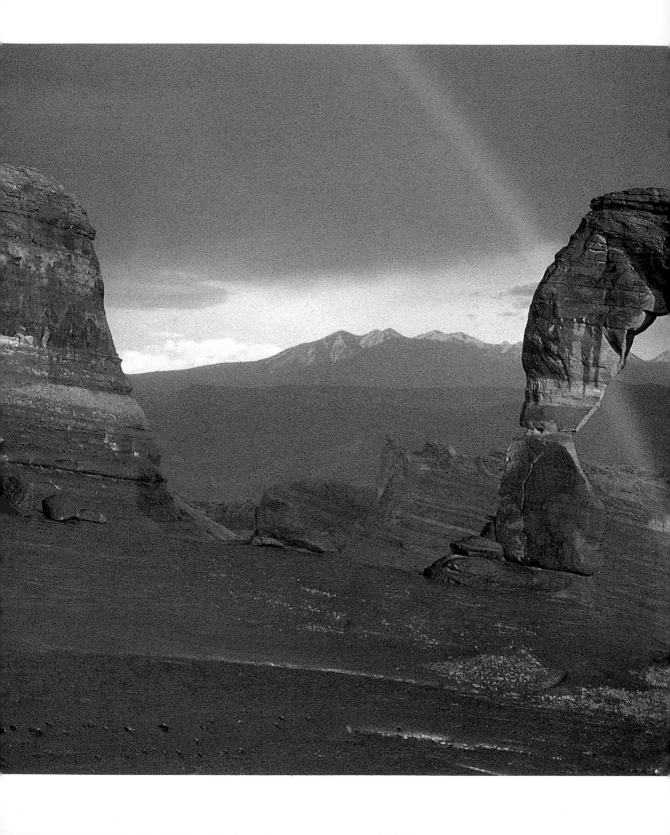

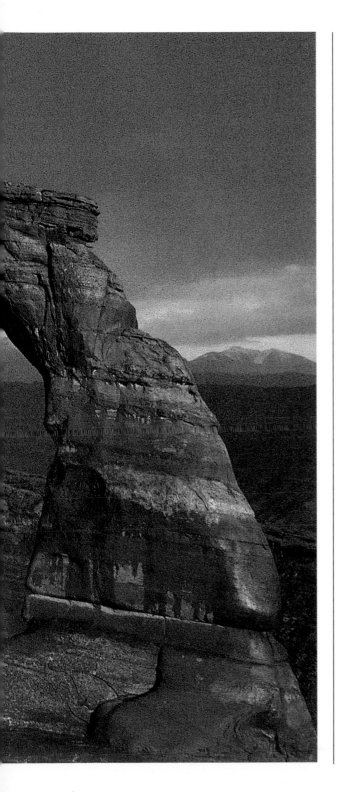

Delicate Arch, with the LaSal Mountains in the background, has been photographed millions of times from the viewpoint at the end of the trail. Despite that, unusual atmospheric conditions can produce unique images. Our workshop group left the parking area in bright sunshine about midafternoon and hiked to the arch. As we waited for sunset, a strong spring thunderstorm moved over the area, and the skies turned black. All of the people left except for our group. The rain came down in sheets, and we all got soaked. We huddled together close to a cliff and tried to protect our cameras as best we could. I kept trying to cheer everyone up, saying that a rainbow might develop. They laughed.

As the brief, violent thunderstorm passed, the sun came out and a beautiful rainbow did develop behind Delicate Arch. It was still raining lightly where we were standing, even though the late-afternoon sun showed beneath the clouds. I had to dry off my filters with a soft cloth between each exposure. The rainbow was intensified by the use of a polarizing filter. Remember that while a rainbow may be beautiful by itself, a rainbow with a dramatic scene is even more desirable.

Delicate Arch and rainbow, Arches National Park, Utah. *Minolta 35–70mm lens, polarizing and enhancing filters, Kodachrome 200 film.*

Arches National Park is my favorite place in all the world. The variety of subject material, both large and small, is infinite. Landscape Arch is the longest known free-standing arch in the world, with a span of 291 feet, almost as long as a football field. The arch is very thin in some places and, geologically speaking, will not last much longer. Over the past several years, a number of small chunks of rock have fallen from Landscape Arch. It may stand for centuries or it may fall tomorrow. Its size, fragility, and beauty all make it a compelling subject.

Landscape Arch in winter, Arches National Park, Utah. *Minolta 24–35mm lens, polarizing and enhancing filters, Fuji Velvia film.*

After a fresh snowfall, all of the features in the canyon country take on a special personality. I attempted to record this image on the morning after the storm. The morning dawned clear, but fog rolled in and blotted out the sun, making photography with early light impossible. After waiting in the damp cold for over an hour, I finally admitted defeat. Two days later, the weather cleared, and I was fortunate to have another opportunity to photograph this composition at sunrise. The snow was still pristine, and the moment was made even more enjoyable by the bitter disappointment I had experienced two days previously.

Photographs of arches are always more impressive when some sky appears below them, so I chose an approximate camera position accordingly. From a considerable distance, I spotted a particularly interesting group of frosted yucca plants below the arch and knew that they would add to the composition, interest, and depth of the picture. Since I wanted to emphasize the foreground, I chose a wide-angle lens and a vertical format for the image.

The Grand Canyon is spectacular, but it's very difficult to photograph. Most photographers mistakenly use a wide-angle lens and try to take in too much. I've found that it's usually more effective to concentrate on one prominent butte with a telephoto lens and use early or late light to isolate it from the rest of the canyon. This image of Mount Hayden from Point Imperial on the North Rim was taken just before shadows engulfed it. I placed the butte in the upper right, with the line of the ridge leading in from the lower left. I waited until the cliff behind Mount Hayden was dark so that the butte would stand out. To obtain my exposure, I took a spot meter reading on the butte.

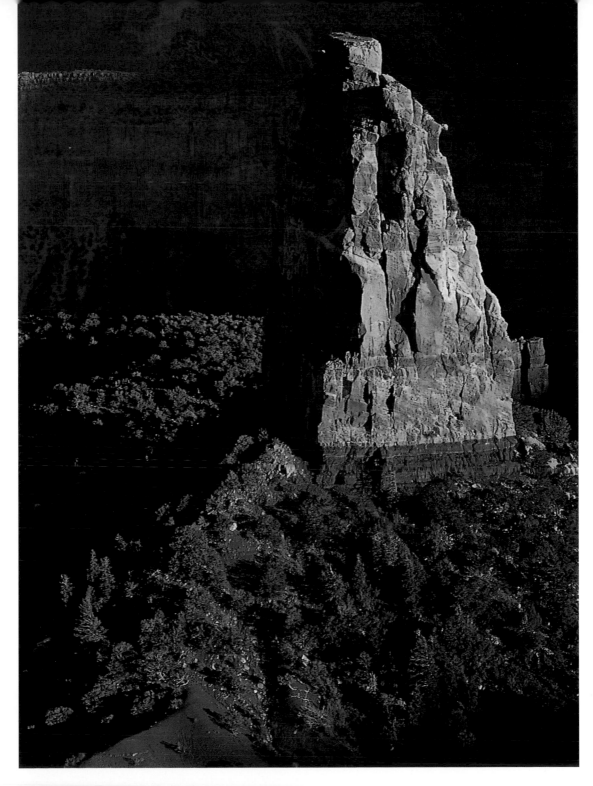

Sunset from Point Imperial, Grand Canyon National Park, Arizona. *Minolta 70–210mm lens, polarizing and enhancing filters, Fuji Velvia film.*

As I waited for the first rays of the sun to strike Mount Moran one cold winter morning, I was moved by the beautiful, subtle colors in the sky. The fog swirling around at the base of the mountain enhanced the soft, ethereal mood. I quickly took a set of photographs. Only moments later, the sun struck the mountains, and the scene became one of high impact with an entirely different mood.

Since the sun was not shining on the snow when this image was made, I took an average meter reading on the whole scene, opened up a half stop, and bracketed the exposure. The air temperature was –20 degrees F. I tried to keep the camera batteries warm by keeping the camera body under my coat between sequences of photographs. Despite these precautions, after the sun came up, two of my camera bodies froze up temporarily. I had frost on my glasses, frost on my rear viewfinder, and frozen feet and fingers, but the images I recorded made all the discomforts and inconveniences worthwhile.

Winter alpenglow, Mount Moran, Grand Teton National Park, Wyoming. *Minolta 70–210mm lens, polarizing and enhancing filters, Fuji Velvia film.*

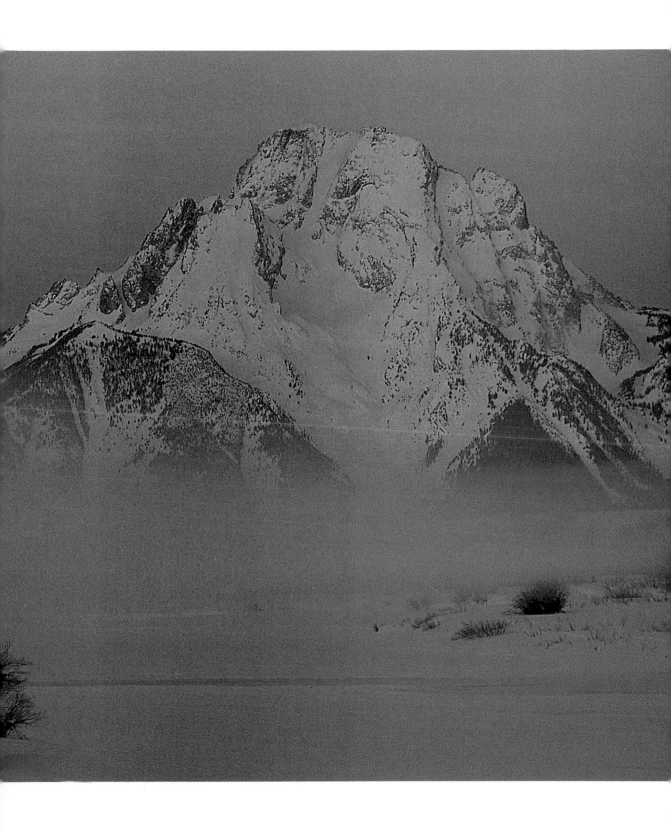

The last morning of our workshop in Joshua Tree and Death Valley National Parks had arrived. The weather had been wonderful all week, and everyone had recorded many images with good subject material and strong lighting. But because of the clear skies, not enough clouds had been present to get any good sunrises or sunsets. As we packed up the van and left our motel in Yucca Valley that final morning, we noticed quite a few high clouds along the eastern horizon, and I anticipated a colorful sunrise. As we sped toward Joshua Tree National Park, it was apparent that we wouldn't reach the park in time for the sunrise. Fortunately, however, there are many Joshua trees outside the park as well. After clearing the town and getting away from telephone poles, we pulled onto a side road where many picturesque Joshua trees were available.

I chose a group of Joshua trees that were far enough away that I could use a 200mm lens to record the scene. This made the sun larger in the frame than with a shorter lens. I was not able to use a longer lens because other Joshua trees limited the positions in which I could set up my camera and still get a clear view. Since I needed to obtain sharp focus on both the Joshua trees and the sun, I shot at f/32 to obtain maximum depth of field. Some thin clouds were along the horizon, so the rising sun did not cause lens flare. I used an enhancing filter to make the sky even more spectacular, took my exposure reading on the sky away from the sun and away from the silhouettes, and bracketed exposures by a half stop on either side of my median exposure. The resulting image was the most successful of the week for the whole group.

Joshua tree sunrise, Yucca Valley, California. *Minolta 70–200mm lens, enhancing filter, Fuji Velvia film.*

Arizona desert sunset, Saguaro National Park, Arizona. *Minolta 70–210mm lens, enhancing filter, Fuji Velvia film.*

Every photographic program or book should end with a good sunset. The sunsets in the cactus country of Arizona are legendary. The key ingredient is finding the compositional elements that make the image more than just beautiful color. I always spend some time just before sunset looking for groups of saguaros that are interesting in shape and balanced in composition. This is not as easy as it may sound. The saguaros chosen must be on high ground so that they will be silhouetted against the sky. Since only the portion of the cacti above the horizon will be seen in the photograph, the horizon should be placed very low in the frame. The area from the camera position to the cacti must be mostly clear so that out-of-focus elements will not be distracting.

Finally, obtaining wonderful color in the sky does not happen every evening. Sometimes too many clouds are present, and other times too few. I set up on this composition on four different evenings before having exactly the right conditions.

The combination of Fuji Velvia film and an enhancing filter will make an average sunset memorable and a good sunset spectacular. Keep in mind that a combination of artistry, luck, patience, and persistence is usually needed to record memorable landscape photographs.

BIBLIOGRAPHY

Adams, Virginia, and Ansel Adams. *Illustrated Guide to Yosemite*. San Francisco: The Sierra Club, 1963.

Lepp, George. "Landscape Depth of Field," *Outdoor Photographer*, March 1996.

Muir, John. *Wilderness Essays*. Salt Lake City: Peregrine Smith Books, 1980.

Patterson, Freeman. *Photography and the Art of Seeing*. Toronto: Van Nostrand Reinhold, 1979.

———. *Photography for the Joy of It*. Toronto: Van Nostrand Reinhold, 1977.

———. *Photography of Natural Things*. Toronto: Van Nostrand Reinhold, 1982.

Shaw, John. *The Nature Photographer's Complete Guide to Professional Field Techniques*. New York: Amphoto, 1984.

Wignall, Jeff. *Landscape Photography, A Kodak Guide*. Rochester, NY: Eastman Kodak Co., 1987.